D0454736

EARLY
ASCENTS
— on —
PIKES PEAK

WOODY SMITH

THE
History
PRESS

GARFIELD COUNTY LIBRARIES
Carbondale Branch Library
320 Sopris Ave
Carbondale, CO 81623
(970) 963-2889 — Fax (970) 963-8573
www.gcpld.org

Published by The History Press
Charleston, SC 29403
www.historypress.net

Copyright © 2015 by Woody Smith
All rights reserved

First published 2015

Manufactured in the United States

ISBN 978.1.46711.839.2

Library of Congress Control Number: 2015942729

Notice: The information in this book is true and complete to the best of our knowledge. It is offered without guarantee on the part of the author or The History Press. The author and The History Press disclaim all liability in connection with the use of this book.

All rights reserved. No part of this book may be reproduced or transmitted in any form whatsoever without prior written permission from the publisher except in the case of brief quotations embodied in critical articles and reviews.

To Mom and Dad.
Thanks for the good brain.

TO THE CARBONDALE
PUBLIC LIBRARY.
IT'S GOOD TO GET OUT!

WOODY
SMITH
2/3/2017

CONTENTS

Pikes Peak Summit. *Photo by Haines Photo Co., August 21, 1908. Library of Congress.*

FOREWORD

Pikes Peak was once the most widely known mountain in the American West. Zebulon Pike failed to reach its summit in 1806, but by the latter half of the nineteenth century, thousands did so annually. The rush toward the peak began after hardy argonauts painted signs of "Pikes Peak or Bust" on their wagons. They headed west in search of gold but were not entirely sure of the peak's location relative to the gold fields. Once they had crossed the plains, however, there was no mistaking the mountain's prominence.

With no other mountains of similar height within a sixty-mile radius, massive Pikes Peak stood as an undisputed landmark. It became a beacon for all who followed. Some pushed past the mountain seeking gold and silver discoveries. Others settled along Colorado's Front Range and in the new town of Colorado Springs. But these were just the vanguard.

Railroads soon brought flocks of tourists to the base of the mountain. While a few adventurers roamed the peak in all seasons, tourists sought the easiest route to the summit in summer. The mountain soon became a "must" on the Colorado tourism circuit. First on foot and by horseback and later by horse-drawn carriage and cog railway, hundreds, then thousands and then tens of thousands reached its lofty top. Many summiteers returned east boasting, "Yes, of course," they had climbed Pikes Peak.

The main ascent route by foot or horse evolved into the Barr Trail. Running from Manitou Springs to the 14,110-foot summit, the trail climbs 7,500 vertical feet in almost eleven miles and remains a grueling one-day outing. A carriage road was constructed to the top in 1889, and

the following year, the Manitou and Pikes Peak Cog Railway was completed to the summit with grades approaching 25 percent. By 1915, an automobile road had replaced the old carriage route.

If one reaches the summit of Pikes Peak on a cold and foggy day and thick clouds encircle the mountain, one may wonder what all the fuss is about. But on a clear day, the views eastward across the plains, westward into the verdant expanse of South Park or north and south along the Front Range awe many a visitor. No wonder that after an 1893 visit, Katherine Lee Bates was inspired to write the words that became "America the Beautiful."

Woody Smith has prowled the archives, newspapers and photo collections of Colorado libraries to assemble an intriguing, firsthand look at what it was like to ascend Pikes Peak and experience the mountain in the early days. Here are stories of tranquil summer outings and posed photographs. But there are also far more rigorous tales of danger during the icy blasts of winter or an ill-fated search for rumored treasure. In such a wild and beautiful place, death was sometimes right over the next rise.

Lace up your boots, straighten your tie or long skirt and step back into the nineteenth century for a trip up one of America's most storied mountains.

Walter R. Borneman is the co-author with Lyndon J. Lampert of A Climbing Guide to Colorado's Fourteeners, *first published in 1978 and in print for twenty-five years. His 2005 book with acclaimed photographer Todd Caudle,* 14,000 Feet: A Celebration of Colorado's Highest Mountains, *remains a Colorado favorite. Borneman's other books include* The Admirals: Nimitz, Halsey, Leahy, and King; *American* Spring: Lexington, Concord and the Road to Revolution; *and* Iron Horses: America's Race to Bring the Railroads West.

FOREWORD

There is the story about Zebulon Pike. When he was out with his small army group, they kept getting lost. At one point, it is told, they planned to go west but went by their compass and headed south, where a Spanish army detachment captured them and held them briefly. Historians found that they had a compass made by the Tate Company in Boston. It seemed to function properly. From this there came a saying: "He who has a Tate's is lost."

I understand that Zebulon was fairly even-tempered, but now and then something would really irk him. This was known as "Pike's Pique."

Woody Smith has performed a wonderful archival feat to rescue accounts of exploits on Pikes Peak in the nineteenth century. Included are verbatim descriptions of early, often harrowing, climbs in all kinds of weather; extensive reports of lightning phenomena; the first death-defying descent via bicycle; and many deaths, some by murder. Readers will find fascinating the very words of these pioneers and newspaper accounts of the day.

Al Ossinger was the 101st person to report climbing all of Colorado's fourteen-thousand-foot peaks (August 1969). Since joining the Colorado Mountain Club in 1965, Al has been club president (1986), served on the CMC Board (1983–86), led at least 154 trips (1972–91) and served as chairman of the Winter Activities Committee (1984–88). He has also written for the CMC magazine Trail & Timberline. *Al has climbed over four hundred fourteen-thousand-foot peaks.*

FOREWORD

When I retired in Pueblo, Colorado, in 1976, I used to occasionally make an early morning drive to Manitou Springs and walk up the Barr Trail to the top of Pikes Peak, where I'd have coffee and a couple of donuts and then ride the cog down or hitch a ride on a tourist bus. Sometimes I would encounter a guy from back east who came out to Colorado Springs every summer and sometimes walked up Pikes Peak two or three times in one day. I was amused when the army paid no heed to his offer to walk up the mountain four times in one day if they would make him the loan of a helicopter. Once, I shared a seat with him on the cog, and he asked what he might do to get the Colorado Springs–Pikes Peak area more attention. Tongue in cheek, I suggested that he walk up the trail naked, but he didn't think that was funny. Anyway, I was not interested in any challenges or marathons. Those walks were pure enjoyment, and I was grateful to Fred Barr for having built the trail.

Woody has artfully and skillfully compiled a lot of information about the early days, and I have scanned an advance copy with interest; I look forward to its publication.

Paul Stewart has been a member of the Colorado Mountain Club since 1954. He joined so he could attend that year's summer outing to Mount Holy Cross, whose co-leader was climbing legend Carl Blaurock. They remained friends until Blaurock's passing in 1993 at age ninety-eight. Stewart's other CMC activities include leading nearly 130 CMC trips all over the state between 1965 and 1990 and serving as editor of the CMC magazine

Trail & Timberline *from May 1977 to May 1978;* T&T *staff, August 1978 to June 1979; and chairman of the El Pueblo Group (1965).*

Paul was born in Cleveland, Ohio, in 1919, served in World War II in the air force and became a civil engineer for the Bureau of Reclamation in 1950. One of his assignments was construction and electrical line inspection at the Glen Canyon Dam (1960–62). Just after dam construction began, Stewart and Blaurock joined a CMC raft trip down Glen Canyon. The trip and construction slides were detailed in the Summer 2009 Trail & Timberline.

PREFACE

The summit of Pikes Peak has been a lure since it was first attempted by Lieutenant Zebulon Pike and members of his expedition in November 1806. The first *known* ascent occurred in July 1820, when three men, including Lieutenant Edwin James, with the U.S. Army's Long Expedition climbed the mountain.

The next *recorded* ascent was made nearly forty years later, in July 1858.

In the years between, knowledge of the mountain grew, but so did its myth, perhaps driven by nineteenth-century hyperbole. In 1830, historian Timothy Felt wrote in *History of the Mississippi Valley*:

> *One mountain is distinguishable from all the rest. We have wished that it might be denominated Mount Pike, from the name of the intrepid and adventurous traveller, who gave us the first account of it. Its black sides and hoary summit are a kind of sea mark at immense distances over the plain. It elevates its gigantic head, and frowns upon the sea of verdure, and the boundless range of buffaloes below, taking its repose, solitary and detached from the hundred mountains apparently younger members of the family, which shrink with filial awe at a distance from it.*

But who was the *first* to climb the peak? Spanish explorers? Indians?

Certainly the Spanish were close enough to have climbed it. In 1779, they fought a battle against the Comanches at the base of the peak in what are now Colorado Springs and Manitou Springs.

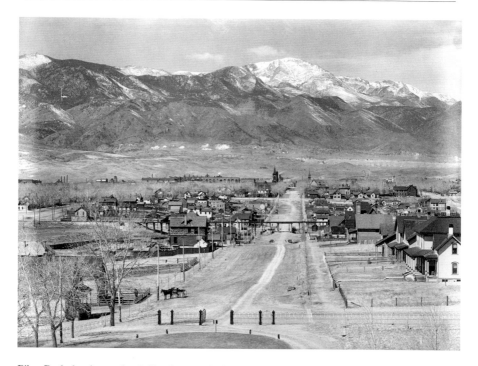

Pikes Peak dominates the skyline from early Colorado Springs, circa 1880. *History Colorado.*

Writes historian John Fetler in *The Pikes Peak People*: "There was also a legend, a tradition, an unconfirmed rumor, that the early Spaniards did climb Pikes Peak, and that early explorers found an altar of rough granite at the summit. If that was the case, the altar has disappeared."

However, archaeological evidence shows that Native Americans preceded the Spanish into the region by about 11,500 years. Given that the peak was climbed by three amateur mountaineers in July 1858 shortly after setting eyes on it, logic dictates that anyone determined to reach the summit could do so, particularly if they were experienced outdoorsmen. Adding weight to this argument is the reported ascent of Pikes Peak in October 1839 by "several hundred" Indians. If accurate, we can assume that the climb was made by thousands of natives in the years between the last ice age and the arrival of Americans in the 1850s.

Almost two hundred years after Edwin James climbed an empty mountain, the annual total of summit visitors is half a million. And while solitude may not be as easy to come by on the train, the road or the summit, there are still thousands of secluded acres where the peak can be experienced as the first mountaineers did—just trail and trees and views.

ACKNOWLEDGEMENTS

T hanks to Coi Drummond-Gehrig of the Denver Public Library, Digital Image Collections administrator; Dennis Daily and Bill Thomas of the Pikes Peak Library District; Melissa VanOtterloo, photo research and permissions librarian; and the Stephen Hart Library, History Colorado. Thanks to the staff at the Denver Public Library, Western History Department, including James Rogers and Ariana Ross. Thanks to Sarah Gorecki of the Colorado Mountain Club Press and to David Hite of the CMC for general support. Thanks to Katie Sauer of the American Alpine Club Library. Thanks to Artie Crisp and The History Press. Thanks to Don Smith and Kathryn Anthoney-Smith.

Special thanks to Walt Borneman, Al Ossinger, Paul Stewart and the Colorado Mountain Club.

INTRODUCTION

To most of us living in the twenty-first century, the people of the 1800s are as worn and faded as their photographs—two dimensional and certainly not capable of the same desire we have to climb mountains. But they were just like us. They did everything we do, just with fewer gadgets and a lot more inconvenience. Would you be willing—as tourists of the 1860s were—to ride a stagecoach over seven hundred miles of bone-jarring ruts *on vacation* to see the fabled Pikes Peak Country? Could you drink the brown well water at the side of the trail or eat their non–vacuum packed, *unpasteurized* vittles? And then, in heavy nineteenth-century clothes—all made of wool and burlap—seek more discomfort by climbing a mountain? With no prospect of a hot shower afterward? Would *you* have made it out the door?

But even then people had it in their minds to climb, and Pikes was a prized trophy on the tourist circuit. Visitors would hike up tenuous trails or endure long hours on the backs of burros or horses, all to experience the "sublime grandeur of a view from the summit."

Fortunately, plenty of local newspapers, and even national magazines, were on hand to report the human and natural events on and around the mountain. Usually, trips to the summit were pleasantly uneventful. On other occasions, when bad weather—or judgment—moved in, the mountain could quickly turn into a nightmare.

What follows is just a fraction of the collected work of dozens of nineteenth-century journalists, some known, most not, and their efforts to document the early days of Pikes Peak and the people who ascended it.

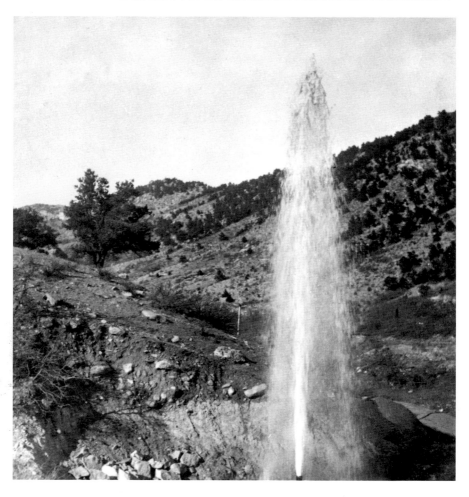

Ute Chief Manitou Spring, one of the attractions at the base of the peak, in its natural state before it was capped and commercialized. It gushed forty-eight feet high and flowed at eight hundred gallons per minute. *Pikes Peak Library District.*

By presenting even a small portion of the peak's long human history, we hope to instill a sense of stewardship in today's visitor and preserve it for future generations.

I am grateful and indebted to the nineteenth-century writers of the:

Appalachia Magazine, Henry Stearns
Buena Vista Herald
Collier's Magazine, W.C. Campbell
Colorado Mountaineer/Weekly Republic and Mountaineer (Georgetown, CO)

Colorado Springs Gazette/Colorado Springs Gazette Telegraph
Colorado Springs Republican
Colorado Transcript (Golden, Jefferson, CO)
Denver Daily Times/Denver Times
Denver Republican
Field & Farm Magazine
Georgetown Miner
Littleton Independent
Manitou Springs Journal
Nature Magazine
Out West Magazine (Colorado Springs, CO)
Pikes Peak Daily News (Summit of Pikes Peak)
Rocky Mountain News (Denver)
Rocky Mountain Sun (Aspen, CO)
Scientific American
Silver World (Lake City, CO)

And writers and historians:

F.W. Cragin
Julia A. Holmes
Edwin James
Rose Pender

The use of apostrophes in place names, such as "Pike's Peak," was phased out after 1890, when the U.S. Board of Geographic Names began standardization across the country. Apostrophes denoted *possession*, which was against board policy.

—Woody Smith
Denver, Colorado
May 14, 2015

PART I
1819-1874

EXCURSION TO THE SUMMIT OF THE PEAK

Excerpt from Edwin James's Account of
Stephen H. Long Expedition, 1819-20
June 1820

At an early hour on the morning of the 13th, Lieutenant Swift, accompanied by the guide, was despatched [*sic*] from camp, to measure a base near the peak, and to make there a part of the observations requisite for calculating its elevation. Dr. James, being furnished with four men, two to be left at the foot of the mountain to take care of the horses, and two to accompany him in the proposed ascent to the summit of the peak, set off at the same time.

This detachment left the camp before sunrise, and taking the most direct route across the plains arrived at eleven o'clock at the base of the mountain. Here Lieutenant Swift found a place suited to his purpose; where, also, was a convenient spot for those who were to ascend the mountain to leave their horses. At this place was a narrow, woodless valley, dividing transversely several sandstone ridges, and extending westward to the base of the peak.

After establishing their horse-camp, the detachment moved up the valley on foot, arriving about noon at the boiling spring, where they dined on a saddle of venison and some bison ribs they had brought ready cooked from camp.

The *boiling spring* [now Manitou Springs] is a large and beautiful fountain of water, cool and transparent, and aerated with carbonic acid...The water

of the spring deposits a copious concretion of carbonate of lime, which has accumulated on every side, until it has formed a large basin overhanging the stream; above which it is raised several feet. This basin is of a snowy whiteness, and large enough to contain three or four hundred gallons, and is constantly overflowing.

The spring rises from the bottom of the basin, with a rumbling noise, discharging about equal volumes of air and of water, probably about fifty gallons per minute; the whole is kept in constant agitation. The water is beautifully transparent; and has the sparkling appearance, the grateful taste, and the exhilarating effect, of the most highly aerated artificial mineral waters.

Distant a few rods from this is another spring of the same kind, which discharges no water, its basin remaining constantly full, and only air escaping from it. We collected some of the air from both these springs in a box we had carried for the reception of plants; but could not perceive it to have the least smell, or the power of extinguishing flame, which was tested, by plunging into it lighted splinters of dry cedar.

…After we had dined, and hung up some provisions in a large red cedar-tree near the spring, intending it for a supply on our return, we took leave of Lieutenant Swift and began to ascend the mountain.

We carried with us each a small blanket, ten or twelve pounds of bison meat, three gills of parched corn meal, and a small kettle.

…The ascending party found the surface in many places covered with such quantities of this loose and crumbled granite, rolling from under their feet, as rendered the ascent extremely difficult. We now began to credit the assertions of the guide, who had conducted us to the foot of the peak, and there left us, with the assurance that the whole of the mountain to its summit was covered with loose sand and gravel; so that though many attempts had been made by the Indians and by hunters to ascend it, none had ever proved successful. We passed several of these tracts, not without apprehension for our lives; as there was danger, when the foothold was once lost, of sliding down, and being thrown over precipices. After labouring with extreme fatigue over about two miles, in which several of these dangerous places occurred, we halted at sunset in a small cluster of fir trees. We could not, however, find a piece of even ground large enough to lie down upon, and were under the necessity of securing ourselves from rolling into the brook near which we encamped by means of a pole placed against two trees. In this situation, we passed an uneasy night; and though the mercury fell only to 54 degrees, felt some inconvenience from cold.

On the morning of the 14th, as soon as daylight appeared, having suspended in a tree our blankets, all our provisions, except about three pounds of bison's flesh, and whatever articles of clothing could be dispensed with, we continued the ascent, hoping to be able to reach the summit of the peak, and return to the same camp in the evening. After passing about half a mile of rugged and difficult travelling, like that of the preceding day, we crossed a deep chasm, opening towards the bed of the small stream we had hitherto ascended; and following the summit of the ridge between these, found the way less difficult and dangerous.

Having passed a level tract of several acres covered with aspen, poplar, a few birches, and pines, we arrived at a small stream running towards the south, nearly parallel to the base of the conic part of the mountain which forms the summit of the peak. From this spot we could distinctly see almost the whole of the peak: its lower half thinly clad with pines, junipers, and other evergreen trees; the upper, a naked conic pile of yellowish rocks, surmounted here and there with broad patches of snow. But the summit appeared so distant, and the ascent so steep, that we began to despair of accomplishing the ascent and returning on the same day.

…The day was bright, and the air nearly calm. As we ascended rapidly, we could perceive a manifest change in temperature; and before we reached the outskirts of the timber, a little wind was felt from the northeast…We found the trees of a smaller size, and scattered more in proportion to the elevation at which they grew; and arrived at about twelve o'clock at the limit above which none are found. This is a defined line, encircling the peak in a part which, when seen from the plain, appeared near the summit; but when we arrived at it, a greater part of the whole elevation of the mountain seemed still before us. Above the timber the ascent is steeper, but less difficult than below; the surface being so highly inclined, that the large masses, when loosened, roll down, meeting no obstruction until they arrive at the commencement of the timber. The red cedar, and the flexile pine, are the trees which appear at the greatest elevation…

A few trees were seen above the commencement of snow; but these are very small, and entirely procumbent, being sheltered in the crevices and fissures of the rock…

A little above the point where the timber disappears entirely, commences a region of astonishing beauty, and of great interest on account of its productions…

…At about two o'clock we found ourselves so much exhausted as to render a halt necessary. Mr. Wilson, who had accompanied us as a volunteer, had been left behind some time since, and could not now be seen in any

direction. As we felt some anxiety on his account, we halted, and endeavored to apprize [*sic*] him of our situation; but repeated calls, and the discharging of the rifleman's piece, produced no answer. We therefore determined to wait some time to rest, and to eat the provision we had brought, hoping, in the meantime, he would overtake us.

We halted at a place about a mile above the edge of the timber. The stream by which we were sitting we could perceive to fall immediately from a large body of snow, which filled a deep ravine on the south-eastern side of the peak. Below us, on the right, were two or three extensive patches of snow; and ice could be seen everywhere in the crevices of the rocks.

Here, as we were sitting at our dinner, we observed several small animals, nearly the size of the common gray squirrel; but shorter, and more clumsily built. They were of a dark gray colour, including to brown, with a short thick head, and erect rounded ears. In habits and appearance, they resemble the prairie dog, and are believed to be a species of the same genus. The mouth of their burrow is usually placed under the projection of a rock; and near these the party afterwards saw several of the little animals watching their approach, and uttering all the time a shrill note, somewhat like that of a ground squirrel. Several attempts were made to procure a specimen of this animal, but always without success, as we had no guns but such as carried a heavy ball.

After sitting about half an hour, we found ourselves somewhat refreshed, but much benumbed with cold. We now found it would be impossible to reach the summit of the mountain, and return to our camp of the preceding night, during that part of the day which remained; but as we could not persuade ourselves to turn back, after having so nearly accomplished the ascent, we resolved to take our chance spending the night on whatever part of the mountain night might overtake us. Wilson had not yet been seen; but as no time could be lost, we resolved to go as soon as possible to the top of the peak, and look for him on our return. We met, as we proceeded, such numbers of unknown and interesting plants, as to occasion much delay in collecting; and were under the mortifying necessity of passing by numbers we saw in situations difficult of access.

As we approached the summit, these became less frequent, and at length ceased entirely…There is an area of ten or fifteen acres forming the summit, which is nearly level; and on this part scarce a lichen was to be seen. It is covered to a great depth with large splintery fragments of a rock entirely similar to that found at the base of the peak, except perhaps a little more compact in its structure. By removing a few of these fragments, they were

found to rest upon a bed of ice, which is of great thickness, and may perhaps, be as permanent as the rocks with which it occurs.

It was about 4 o'clock P.M. when the party arrived on the summit. In our way we attempted to cross a large field of snow, which occupied a deep ravine, extending down about half a mile from the top, on the south-eastern side of the peak. This was, however, found impassable, being covered with a thin ice, not sufficiently strong to bear the weight of a man. We had not been long on the summit when we were rejoined by the man who had separated from us, near the outskirts of the timber. He had turned aside and lain down to rest, and afterwards pursued his journey by a different route.

From the summit of the peak, the view towards innumerable mountains, all white with snow; and on some of the more distant it appears to extend down to their bases. Immediately under our feet, on the west, lay the narrow valley of the Arkansa [sic], which we could trace running towards the north-west, probably more than sixty miles.

On the north side of the peak was an immense mass of snow and ice. The ravine in which it lay terminated in a woodless and apparently fertile valley, lying west of the first great ridge, and extending far towards the north. This valley must undoubtedly contain a considerable branch of the Platte. In a part of it, distant probably thirty miles, the smoke of a large fire was distinctly seen, supposed to indicate the encampment of a party of Indians.

To the east lay the great plain, rising as it receded, until in the distant horizon it appeared to mingle with the sky. A little want of transparency in the atmosphere, added to the great elevation from which we saw the plain, prevented our distinguishing the small inequalities of the surface. The Arkansa, with several of its tributaries, and some of the branches of the Platte, could be distinctly traced as on a map, by the line of timber along their courses.

On the south the mountain is continued, having another summit, (supposed to be that ascended by Captain Pike,) at the distance of eight or ten miles. This, however, falls much below the high peak in point of elevation, being wooded quite to its top. Between the two lies a small lake, apparently a mile long, and half a mile wide, discharging eastward into the Boiling-spring creek. A few miles farther towards the south, the range containing these two peaks terminates abruptly.

The weather was calm and clear while the detachment remained on the peak; but we were surprised to observe the air in every direction filled with such clouds of grasshoppers, as partially to obscure the day. They had been seen in vast numbers about all the higher parts of the mountain, and many

had fallen upon the snow and perished. It is, perhaps, difficult to assign the cause which induces these insects to ascend to those highly elevated regions of the atmosphere. Possibly they may have undertaken migrations to some remote district; but there appears not the least uniformity in the direction of their movements. They extended upwards from the summit of the mountain to the utmost limit of vision; and as the sun shown brightly, they could be seen by the glittering of their wings, at a very considerable distance.

About all the woodless parts of the mountain, and particularly on the summit, numerous tracks were seen, resembling those of a common deer, but most probably have been those of the animal called the big horn. The skulls and horns of these animals we had repeatedly seen near the licks and saline springs at the foot of the mountain, but they are known to resort principally about the most elevated and inaccessible places.

The party remained on the summit only about half an hour; in this time the mercury fell to 42 degrees, the thermometer hanging against the side of a rock, which in the early part of the day had been exposed to the direct rays of the sun. At the encampment of the main body in the plains, a corresponding thermometer stood in the middle of the day at 96 degrees, and did not fall below 80 degrees until a late hour in the evening.

Great uniformity was observed in the character of the rock about all the upper part of the mountain. It is a compact, indestructible aggregate of quartz and feldspar, with a little hornblende, in very small particles. Its fracture is fine, granular, or even; and the rock exhibits a tendency to divide when broken into long, splintery fragments...It is not improbable that the splintery fragments, which occur in such quantities on all higher parts of the peak, may owe their present form to the agency of lightning. No other cause seems adequate to the production of so great an effect.

Near the summit some large detached crystals of feldspar, of pea-green colour, were collected; also large fragments of transparent, white and smoky quartz, and an aggregate of opaque white quartz, with crystals of hornblende.

At about five in the afternoon the party began to descend, and a little before sunset arrived at the commencement of the timer; but before we reached the small stream at the bottom of the first descent, we perceived we had missed our way. It was now become so dark as to render an attempt to proceed extremely hazardous; and as the only alternative, we kindled a fire, and laid ourselves down upon the first spot of level ground we could find. We had neither provisions nor blankets; and our clothing was by no means suitable for passing the night in so bleak and inhospitable a situation. We could not, however, proceed without imminent danger from precipices; and

by the aid of a good fire, and no ordinary degree of fatigue, found ourselves able to sleep during a greater part of the night.

15th. At day break on the following morning, the thermometer stood at 38 degrees. As we had few comforts to leave, we quitted our camp as soon as the light was sufficient to enable us to proceed. We had travelled about three hours when we discovered a dense column of smoke rising from a deep ravine on the left hand. As we concluded this could be no other than the smoke of the encampment where we had left our blankets and provisions, we descended directly towards it. The fire had spread and burnt extensively among the leaves, dry grass, and small timber, and was now raging over an extent of several acres. This created some apprehension lest the smoke might attract the notice of any Indians who should be at that time in the neighbourhood, and who might be tempted by the weakness of the party to offer some molestation. But we soon discovered a less equivocal cause of regret in the loss of our *cache* of provisions, blankets, clothing, &c. which had not escaped the conflagration. Most of our baggage was destroyed; but out of the ruins we collected a beggarly breakfast, which we ate, notwithstanding its meanness, with sufficient appetite. We chose a different route for the remaining part of the descent from the one going up, and by that means avoided a part of the difficulty arising from the crumbled granite; but this was nearly compensated by the increased numbers of yucca and prickly pears.

We arrived a little after noon at the boiling spring, where we indulged freely in the use of its highly aerated and exhilarating waters. In the bottom of both of these springs a great number of beads and other small articles of Indian ornament were found, having unquestionably been left there as sacrifices or presents to the springs, which are regarded with a sort of veneration by the savages. Bijeau assured us he had repeatedly taken beads and other ornaments from these springs, and sold them to the same savages who had thrown them in.

A large and much frequented road passes the springs, and enters the mountains, running to the north of the high peak. It is travelled principally by the bisons, sometimes also by the Indians; who penetrate here to the Columbia.

The men who had been left at the horse-camp about a mile below the springs, had killed several deer, and had a plentiful supply of provisions. Here the detachment dined; then mounting our horses, we proceeded towards the encampment of the main body, where we arrived a little after dark, having completed our excursion within the time prescribed.

CRAGIN'S EARLY FAR WEST NOTEBOOK
October 1839

In October of that year, a large party of trappers and Indians went up to see the Indian races about (two miles) from what were then known as the "Arapahoe Springs," now known as Baker's Springs in Denver. These springs are on 7th St. near Champa St. [on the Auraria Campus]. The party consisted of Kit Carson, Jim Beckwourth, Oliver Wiggins, Jack McGaa, Joe Hinckley, Julius and William Montbleu, two of the Lajeuness boys, deBluery and other trappers to the number of about twenty in all, besides about twice that number of Taos Indians and Mexicans. Joe Hinckley had with him 2 fine race horses and Carson one. Several hundred Kiowas joined them on the Arkansas, bringing with them a number of race-horses and some very good ones. When they reached the "Medicine Springs," now Manitou, Colorado, they found already congregated there over three thousand Indians, including Sioux, Cheyennes, Arapahoes and Utes. For here, and here alone, the Utes could meet the plains tribes on peaceful footing; to fight at this sacred locality would have been "bad medicine"…With the Kiowas and the party from Taos, there were altogether nearly 4000 souls assembled at this long-time famous locality. "Not a bit of mischief" was done by one tribe to another. (The law of the locality was that, if one tribe left, no other tribe could leave till after "one sleep.") It was a great time of sparking on the part of the young bucks and squaws; an intertribal picnic so to speak. Parties of young Sioux, Cheyennes, Arapahoes & Kiowas mingled without tribal distinction, wandered into the Garden of the Gods…One party of several hundred was made up for Pike's peak, and climbed it to the summit taking two days for the ascent and return.

PIKES PEAK DAILY NEWS
Circa mid-1850s

Early in the [1850s], at a point starting from old Summit park, some fourteen miles west of Manitou, a sort of an apology for a trail was hacked out that lead [*sic*] to within a short distance of the desired place. This was the original pathway used, but as the trail was not very clearly established, and the way

was somewhat long and dangerous, only a few of the boldest and most venturesome travelers availed themselves of its use. [In] 1871–3 and 1877, respectively, to meet the increasing demand for shorter and more direct routes to the summit, three other trails were constructed.

THE TRAIL

July 1858

Kit Carson said that the first white man to ascend that landmark was William B. Parsons [1858]. Of the women who have climbed the peak,

Manitou Springs tourists set for a hike up the Ruxton Creek on the Pikes Peak Trail, 1878. *James Thurlow photo, Denver Public Library, Western History Collection.*

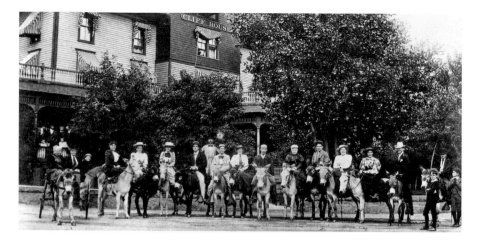

Tourists pose on their burros before setting off from the Cliff House Hotel, Manitou Springs, circa 1870s. *Denver Public Library, Western History Collection.*

Julia Archibald Holmes, a pioneer suffragette in black, close-fitting trousers, hickory shirt and moccasins, led the way.

THE FIRST WOMAN TO CLIMB PIKE'S PEAK

Julia Archibald Holmes's Personal Correspondence August 1858

In July 1858, Julia Archibald Holmes arrived in Colorado with her husband, James, as part of the first "Pikes Peak gold rush" wagon trains. After three of the men successfully made it up the peak, Julia, a strong-willed twenty-year-old, decided she wanted to climb it, too. Though "nearly everyone tried to discourage me from attempting it…I believed I should succeed." Her husband was not easily convinced, but after a few weeks he finally gave in. On August 1, 1858, their climb began:

After an early breakfast this morning my husband and I adjusted our packs on our backs, and started for the ascent of Pikes Peak. My own pack weighed 17 pounds, nine of which were bread, the remaining a quilt and clothing. James' pack weighed 35 pounds, and was composed as follows: 10 pounds bread, one pound hog meat, three fourths pound coffee, one pound sugar, a tin plate, knife and fork, half gallon canteen, half gallon tin pail, and a tin cup, five quilts,

clothing, a volume of Emerson's essays and writing materials made up the remainder. We calculate on this amount of food to subsist six days.

A walk of a mile brought us to the crossing of Boiling Springs river. It is an impetuous, ice cold stream at this point, about 12 feet wide and knee deep with a cobble stone bottom. Undressing our feet we attempted it several times before we could cross, the water was so intensely cold we were ready to drop down with pain on reaching the opposite bank.

Three miles further we reached the wonderful Boiling Springs, which Fremont has made known to the world in his expeditions. There are but three which we noticed. The strong carbonated waters mingled with bubbles of carbonic gas, boil continually, in the rock fountains in which they are set by nature better than they could be by art. In the center of the broad, solid rocks somewhat elevated above the ground around them, composed by the deposition of their own waters, these springs ceaselessly boil.

Leaving the springs, they aimed for the summit. The going was not easy, and after a few miles, they stopped at another spring to refill their canteens and decided to spend the night.

It is now ten o'clock in the evening, and 1 am reclining before some blazing pine logs beside a torrent in a mountain canyon several hundred feet deep. The straight, slender, tapering pines that stand around so beautiful in their death, smooth, white and sound, having been stripped of their bark by fire, calmly point to a sky more serene, and to stars far brighter than usual. The trees and the sky almost seem to strive together in preserving a deeper silence, but there is music from the foaming stream, sounds from a dozen little cascades near and far blend together—a thundering sound, a rushing sound, a rippling sound, and tinkling sounds there are; and a thousand shades of sound to fill up between them.

The burning pine crackles and snaps, showering sparks, cinders and even coals around and all over the sheet I am writing on, as if to mock the tame thoughts they light me to write.

On August 2, 1858, the pair climbed higher, camping the next three nights at another spring about two miles below the summit. From the camp she called Snowdell, Julia wrote:

Eastward we can look on a landscape of Kansas plains, our view hemmed only by the blue haze of the atmosphere, and extending perhaps 200 miles. The beauty of this great picture is beyond my powers of description.

Down at the base of the mountain the corral of 15 wagons, and as many tents scattered around it, form a white speck, which we can occasionally distinguish. We think our location grandly romantic.

Finally, on August 5, 1858: "We left Snowdell, for the summit, taking with us nothing but our writing materials and Emerson." The artistic couple deviated to roll rocks into a

yawning abyss. Starting those stones had been a favorite amusement of those who ascended before us, and it savored somewhat of the terrible…

After enjoying this sport a short time we proceeded directly up towards the summit. Arriving within a few hundred yards of the top, the surface changed into a huge pile of loose angular stones, so steep we found much difficulty in clamboring [*sic*] up them. Passing to the right of a drift of a snow some three or four hundred yards long, which sun and wind had turned into coarse ice, we stood upon a platform of near 100 acres of feldspathic granite rock and boulders. Occasionally a little cranny among the rocks might be found in which had collected some coarse soil from the disintegration of the granite, where in one or two instances we found a green tuft about the size of a teacup from which sprung dozens of tiny blue flowers most bewitchingly beautiful. The little ultra-marine colored leaves of the flower seemed covered with an infinitude of minute sparkling crystals—they seemed children of the sky and snow.

It was cold and rather cloudy, with squalls of snow, consequently our view was not so extensive as we had anticipated. A portion only of the whitened backbone ridge of the Rocky Mountains which forms the boundary line of so many territories could be seen 50 miles to the west.

We were now nearly 14,000 feet above the sea level. But we could not spend long in contemplating the grandeur of the scene for it was exceedingly cold, and leaving our names on our large rock, we commenced letters to our friends, using a broad flat rock for a writing desk. When we were ready to return I read aloud the lines of Emerson:

A ruddy drop of manly blood
The surging sea outweighs;
The world uncertain comes and goes,
The lover rooted stays

I have accomplished the task which I marked out for myself, and now I feel amply repaid for all my toil and fatigue…And now, here I am, and I feel that I would not have missed this glorious sight for anything at all.

In all probability I am the first woman who has stood upon the summit of this mountain, and gazed upon this wondrous scene which my eyes now behold...

Leaving this cloud-capped region, we were soon in *Snowdell*, where we remained only long enough to make up our packs. Before we were ready

On the trail to Pikes Peak, circa 1882–1900. *William H. Jackson Photo. Denver Public Library, Western History Collection.*

A burro party of one man and five women on the Pikes Peak Trail, circa 1900. *L.C. McClure photo, Denver Public Library, Western History Collection.*

to say "goodbye" the snow was falling quite fast, and we left our pretty home as we first saw it, in a snowstorm.

We pursued our journey in all possible haste, anxious to find a good camp for the night before dark. At last when I thought I could not go a rod further, we found a capital place, a real bear's den it seemed, tho large enough for half a dozen. And here we are, enclosed on every side by huge boulders, with two or three large spruce trees stretching their protecting arms over our heads.

The next day near noon we arrived at camp where we found some excitement existing [over] an attempt which the Indians had made the night before to drive away the cattle belonging to the train.

PIKE'S PEAK

Rocky Mountain News
September 6, 1860

A private letter from A.D. Richardson, Esq., of the *Western Mountaineer*, dated at Colorado gives us an item or two of interest.

Mr. R. accompanied by another gentleman and two ladies, left this city some ten or twelve days since for an excursion to Pike's Peak. The weather was very unfavorable while the ascent was being made and the Peak was covered with snow. The party suffered a good deal from cold, want of provisions, stormy weather, etc., and what was undertaken as a pleasure excursion proved a disagreeable, not only, but perilous undertaking. Mr. R. considers the ascent of the Peak almost impossible for women, and nothing but *pluck* ever took the ladies of the party through. They were the first ladies who ever set foot upon the summit and their names should be recorded. Mrs. Blunt and Miss Ada Smith, of Golden city.

Mr. R. did not return to Denver with the party. He designs going to Bent's Fort to attend the council with the Indians, on the 15th inst. In the vicinity of Colorado, the opinion is entertained that all the Indian tribes except the Arapahoes, are hostile to the whites, and will prove troublesome.

LOST ON PIKE'S PEAK

Rocky Mountain News
August 17, 1871

A week or ten days ago, as the story goes, a party of three or four gentlemen, strangers in the country, who happened together in Colorado City, planned a trip to the top of Pike's peak. Provided with only a meagre [*sic*] stock of rations, a bundle of blankets, and walking sticks for each, the enthusiastic explorers started out on foot, without guide or compass.

Now everyone knows that the trail from Colorado City up the ancient mountain is remarkably free from the ordinary complexities of travel. Indeed it is a route a child might travel, and not go amiss, provided, of course, the old folks were ahead. The trail traverses a canon, a most extraordinary gorge, inclosed [*sic*] with stupendous walls. The explorers deported themselves rather leisurely, and in the twilight of the first day, on the nose of a promontory overlooking the plains, they spread their

grateful blankets, and engaged in pleasant dreams. Morning came, but no sun blazed athwart the eastern sky. But a dense fog, of a decidedly spongious consistency, enveloped the travelers with its appalling weight. There was neither sun that day or stars that night. The hours of the second morning came—but there was no daylight, no sun, no sky; only a mountain of fog piled on a mountain of rock. Brief notes of passionate endearment, chiefly to wives and sweethearts, but not a line to anxious creditors, were hastily indited [*sic*], and these were "mailed" by the trailside; even fervent prayers, we are assured, freely indulged in, and the supplicating syllables, loaded with anguish, ascended through the imperiling gloom. They didn't like the idea of being squeezed to death by fog, and especially on Pike's peak, and such a nasty fog at that. So they continued praying, and wandering, and falling—over bowlders [*sic*] and over each other. They relate that they only knew by the sense of touch that the ground was yet beneath them. Now it is a startling fact that these poor fellows continued in a sort of tread-mill trudging for three long days and nights. They roamed about with clasped hands and cautiously advancing toes.

Finally, we believe on the fourth day, when nearly consumed by the pangs of hunger, and just as they were about hanging their skeletons on the bushes, the great fog floated up like Elijah's chariot, and the trees and the plains and the sky reappeared. They struck out down the trail, in a state of extreme exhaustion, feebly d--ing the man that discovered the peak, and were soon in the land of biscuits.

ROCKY MOUNTAIN NEWS

September 9, 1871

About half way up the Pike's Peak trail, a four-roomed house has been erected for the convenience of tourists. It has been aptly termed the "half-way house," and it is believed that the ascent to the top of the Peak can be made as late as the middle of November.

OUT WEST MAGAZINE

June 8, 1872

Parties are already being organized for the ascent of Pike's Peak.

Sheltered Falls on the Pikes Peak Trail, circa 1880s. *William H. Jackson photo, Denver Public Library, Western History Collection.*

Halfway house on the Pikes Peak Trail, built and operated by Thomas Palsgrove, circa 1880s. *William H. Jackson photo, Denver Public Library, Western History Collection.*

The First Ascent of Pike's Peak [August 1858]

Out West Magazine, June 27, 1872
Reprinted from the Kansas Magazine

Soon after leaving Bent's [Fort] we caught the first view of Pike's Peak. We stopped the train and took a good long look. Moses stood upon the mountain and gazed upon his promised land; and we stood upon the plain and gazed upon our mountain. It was some eight thousand feet higher than most of us had ever seen, and its head was white with everlasting snow. It was, after all, not a wonderful mountain, but, by a sort of synecdoche, it was to us everything. It stood for the whole country, from Mexico to our northern line. It represented gold, and plenty of it; it spoke influence, power, and position in our middle age, and ease and comfort in our decline. I think with that first view of the celebrated mountain, we felt the first quickening of a definite purpose; and from that time forward, instead of wandering along with indifference, we selected our daily routes and measured out time with especial reference to the speedy discovery of the grassy canon in the big hill where Fall-Leaf watered his pony. At all events our cattle traveled faster, we were out of camp earlier in the morning and we drove later at night.

The 3^d day of July, we left the Arkansas and passed over the "divide" to the Fountain-qui-Bouille, a stream which emerges from the mountains under the north side of Pike's Peak, and flows southward along the base of the range into the Arkansas at Pueblo San Carlos.

A patriotic impulse moved (and a stampede of stock compelled) us to remain at this point a day or two; and so we planned, and successfully carried through the first formal celebration of our nation's birth day that ever took place within the shadow of the mountains. We fired a salute at sunrise, read the declaration, made speeches, hoisted a flag, had a dance, and fire-works in the evening, and kept open wagons and open kegs for our friends all day. On the second day following, we drove to the Peak, and established a permanent camp precisely where Colorado City now stands. Nature must have constructed this nook in her pleasant moods, and embellished it in her angry ones. The beautiful broad plateau, the due proportion of hills and green valleys, the three clear, cold streams that come tumbling from the mountains at different points, and hasten on with rippling music to mingle into one, the heavy foliage of a hundred hues, from the deep dark evergreens to the brightest rainbow tints would together make up a landscape of quiet beauty. But when these are added to the vast detached rocks, three hundred feet in height,

tremendous chasms two thousand feet in depth, and the old mountain itself towering above the thousand lesser ones like a giant sentinel over a sleeping camp—all upheaved and thrown together by some terrible convulsion in the morning of the world—the scene becomes one of solemn grandeur.

After becoming firmly settled in our camp we prepared to ascend the Peak. We had been told by the Frenchmen at Bent's Fort that no man ever stood upon its summit, and no man ever would. But we thought the thing could be done, and we set about it. We did it. A party of four left camp early in the morning, and reached the highest point at sunset. The distance was about twelve miles, and the time about twelve hours. It was a little tiresome, and the air was very thin, but it was not a serious task by any means. Hooker would march an army up easily if there were rebels at the top.

I have seen several later ascensions recorded in Colorado papers as the first, and I particularly noticed in a Denver paper some time ago an account of several ladies making the trip, and one of them was named as the first woman who ever stood upon the summit of Pike's Peak. I am sorry to spoil the little story, and deprive said lady of her laurels; but the plain fact is, that one of *our* before-mentioned ladies ascended the mountain in question during the last week in July, 1858 [*sic*]. She remained up there two days and nights, slept upon the eternal snow, and wrote letters to the Eastern press dated at the summit. She did not claim to be a heroine, by any means; but if a record is to be made at all, it should be accurate, and I therefore register *our* woman's name, Mrs. Julia Archibald Holmes, then a resident of Kansas, but latterly of Washington, D.C., and Secretary of some national organization of women. She is probably the first woman who ever stood upon a point on the American continent anywhere near 14,000 feet above the level of the sea, and, for aught I know, the first woman who ever stood that high anywhere.

OUT WEST MAGAZINE/ CRAGIN'S EARLY FAR WEST NOTEBOOK
Summer 1872

Hardly a night now passes but the blaze of one or more camp-fires can be seen at the timber-line of Pike's Peak from this point. The fine trail from Manitou to the Peak which was constructed last year by the Colorado Springs Company, has become so well worn as to make the trip a task of comparative

ease. Large numbers of visitors, including ladies, are improving the facilities thus offered to look down upon one of the grandest views that this continent affords, and all return loud in their praises of this delightful trip.

DENVER DAILY TIMES

June 26, 1872

Everybody will be looking towards Pike's Peak on the Fourth. A pyrotechnic display from the pinnacle of the Peak is arranged for that evening, at 9 o'clock, and people whose range of vision extends clearly for seventy-five miles, can see the show.

OUT WEST MAGAZINE

July 11, 1872

Pike's Peak is almost thronged with climbers. The ascent may now be made on a mule or burro to about halfway beyond timber-line, beyond which point the aspiring mountaineer must carry his own burden.

CRAGIN'S EARLY FAR WEST NOTEBOOK

1873

An 1864 pioneer of Colorado City "says there was a trail up Bear Creek in the [1860s]. It was the commonly used route for climbing Pike's Peak; was not a *built* trail, but made chiefly by the wear of 'heels and hoofs,' an occasional stone or two, here and there, probably being thrown out of the way by a mountain climber."

The first *improved* Bear Creek Trail was built in 1873 by Edward Copley and E.S. Nettleton, resident engineer of the Colorado Springs Co. "It went to Lake Moraine and thence on to the top of Pike's Peak. This was probably

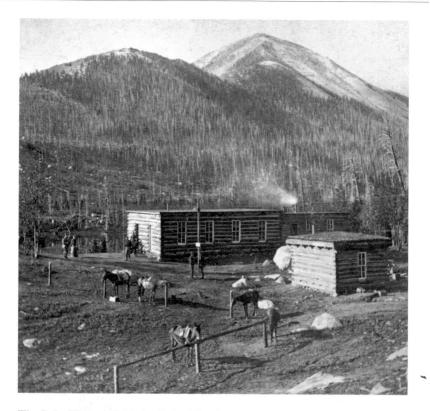

The Lake House at Moraine Lake. Pikes Peak Trail, circa 1870s. *History Colorado.*

Opposite, top: Tourist horses switchback up the Pikes Peak Trail, circa 1880s. *W.E. Hook photo, Denver Public Library, Western History Collection.*

Opposite, bottom: Rosemma Falls on the Pikes Peak Trail, 1880s. *William H. Jackson Photo. Denver Public Library, Western History Collection.*

through arrangement made by the Colorado Springs Company (or Gen'l Palmer) with the U.S. Signal Service, which later improved and maintained the trail; and was in the summer of 1873 just before the Signal Station was built (in October) was estab'd or a bit earlier. Mr. Copley took up the land at Lake Moraine and built there. The 'Lake House,' where he lived for several years, maintaining the house as stopping place for travelers to the Pike's Peak summit. It was also a telegraph office, being served by the U.S. Signal Service's telegraph line to the Summit Station."

There was a trail up Pike's Peak via Bear Creek long before 1871, made by *use.*

CRAGIN'S EARLY FAR WEST NOTEBOOK

July 4, 1873

Charles E. Aiken "says he was on top of Pike's Peak July 4, 1873 for the first and only time. Climbed about the peak often later—even above timber line; but never went up again on to the summit. At that date the first U.S. Signal

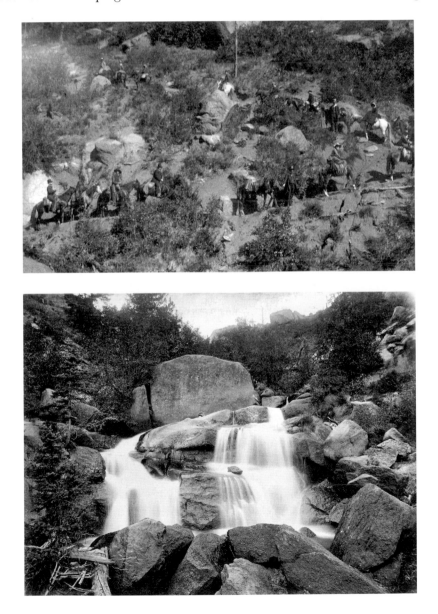

Station had not yet been built. The only structure on the Peak at that time was a cairn about 3½ ft. high, rudely made by piling up granite blocks. It had a small cavity in its top, in which, covered over by a stone, were cards, addresses and scribbled notes that visitors had left there."

LOST ON PIKES PEAK

Denver Daily Times
July 22, 1873

One day last week a party of several ladies and gentlemen attempted the ascension of Pike's Peak. They reached the timber line, when one of the party, an elderly lady who had passed her three score years,

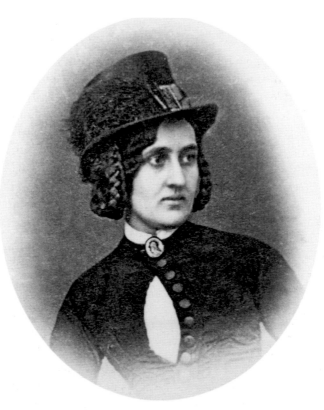

New York Times correspondent and local celebrity Grace Greenwood climbed to the Signal Station on November 22, 1873. She also owned a "cottage" in Manitou Springs. *Pikes Peak Library District.*

concluded to give up the task. Some of the party proposed staying with her, but she declined the offer, saying that she would rest awhile, and then follow on in the trail as far as she was able. The party left her and continued to the top of the peak—about three hours distant. On their return they were unable to discover her. It was decided that part of the company should return to camp, while others would remain and look for the lost one. After a diligent search of four hours she was found, having wandered a considerable distance from the trail.

THE KNIGHTS TEMPLAR EXCURSION

Rocky Mountain News
August 20, 1873

Last Tuesday morning the members of the Colorado Commandery set out upon their long talked of excursion to Manitou. The turnout was not nearly so large as it should have been,—not half so large as promised,—yet there was a very pleasant party, increased by guests from Cheyenne and other points until it filled two cars. The run to the Springs station, and the stage ride thence to Manitou, were without notable incident, the latter place being reached for dinner. Most of the party set out sightseeing, and, as the majority had never before been in that region, they had plenty to occupy all the leisure time of their stay. Excursions were made daily to the Garden of the Gods, Glen Eyrie, Monument park, Williams canon, Cheyenne canon, and many other places of note and interest. The Knights paraded for an hour's drill each morning at 630 o'clock, and each evening at 530 o'clock. The Gilman band which accompanied them opened and closed each day with martial music from the broad verandah of the Manitou house, and played for the social hop in the spacious dining room each evening. The hops, given by the house, were well attended, and a wide and pleasant acquaintance was made between the excursionists and other guests of the house and citizens of the town.

Wednesday evening, Grace Greenwood gave an admirable entertainment of character representations and recitations in the parlors of the hotel, out of compliment to the Knights Templar and their guests. The rooms were crowded to their utmost, and everybody intensely pleased and interested. She gave "Over the hill to the Poor-house"; "The United

States Senate, as seen from the gallery," Bret Harte's "Sicily, or the poet of Alkali Station"; "Laughing Dick," and "Tabitha Tattle"; all of which were loudly cheered.

Thursday morning at 6 o'clock, [nine] Sir Knights set out from the Springs to ascend Pike's Peak. [The Sir Knights were from Denver; Central City; Atchison, Kansas; Omaha, Nebraska; Madison, Wisconsin; and Chicago, Illinois.] They went up the old trail, reaching timber line in a little over three hours. There they left their horses. Some climbed to the summit in less than two hours, from timber line, and the balance followed rapidly after. At 1 o'clock a commandery was opened upon the lofty summit of the great mountain, in a little rocky plateau, cut off from the main table-like surface by a ridge of higher rocks and looking out over a boundless extent of plain, the South park and a wilderness of mountains reaching north to Wyoming, west to the National range, and south to New Mexico. The Commandery being opened the Eminent Commander said:

"Sir Knights:—We are permitted to-day to participate in an event like of which probably never before occurred in the history of the world—to meet in our solemn conclave upon this 'highest hill' overlooking one of the broadest and grandest views to be enjoyed on earth. When those frail bodies shall have turned to dust, and 'true and courteous Sir Knights' of future generations shall 'march to our posts,' rest assured that this event of this day will yet live in Masonic history."

The Sir Knights then engaged in drill, and the full manual of arms in use by the order, after which the conclave was duly closed and the descent begun. It was "severe duty" for some, but the hard climb up and down was made cheerfully, and probably not one would surrender the recollection of the day despite the hardships for any mercenary consideration. All were back safely to Manitou before sunset; the entire trip having occupied less than twelve hours. But seldom has it been made in so short time, and it is even more seldom that in so large a number all succeed in reaching the top. The common time for the expedition occupies a day and half.

An associated press [sic] dispatch was sent from the signal station on the peak. Men were there preparing the foundation for the house that is to be erected. The new trail is completed by which all supplies, building material, fuel, etc., are packed up. Tourists can now ride to the summit with ease and comfort, but it is considerably longer than the old route.

At Thursday night's Manitou hop the Knights appeared in full regalia. Yesterday morning nearly all went to Colorado Springs station, took dinner, and in the afternoon returned to Denver. A few remained at the springs. Throughout four days of the excursion there was not one word or incident to mar the harmony of the occasion, and all returned home well pleased with their holiday. Messrs. Blake & Co., and all their attaches of the Manitou house, exerted themselves to please, and succeeded so well as to elicit nothing but praise from one and all.

FROM THE TOP OF PIKES PEAK

Denver Daily Times
September 19, 1873

The following dispatch was received in Denver from the summit of Pike's Peak, by telegraph, last evening:

"Pike's Peak, Sept. 18.—At 1 o'clock today Colorado Commandery No. 1 Knights Templar convened in special conclave on the summit of this mountain, opening the commandery in ample form. Probably no similar Masonic body ever before held a meeting over 14,000 feet above sea level. The weather was delightful and the view magnificent. After the meeting the Knights engaged in parade and drill, going through the entire manual of arms in use by the order. From the summit of the great mountain, Colorado Commandery sends *courteous greetings to officers* of the General Grand Encampment of the United States and to all Sir Knights."

DENVER DAILY TIMES

December 11, 1873

It has been snowing on Pike's Peak all day.

DENVER DAILY TIMES
December 20, 1873

From all around us come reports of a coming storm. The Pike's Peak station is enveloped in clouds, with a thermometer at 7 o'clock indicating 4° above zero. Santa Fe reports "cold, cloud, and strong indications of a storm." Colorado Springs, "cold, expect snow; thermometer 12° above." Central, "cloudy, calm." Georgetown, "overcast and cold; thermometer 35° above." Cheyenne, "clear and pleasant." It will be seen at a glance that this report is unusual; Cheyenne reporting pleasant weather and Colorado Springs cold and cloudy. The reverse is generally the case. Indeed, we heard intimations that in all probability the Cheyenne man did not stick his head out of doors.

FROZEN ON PIKE'S PEAK
Denver Daily Times
January 10, 1874

A dispatch from Colorado Springs, says: January 3rd the thermometer on Pike's indicated 23° below zero. Assistant Observer Cramer went out that morning to repair the Peak wire. Sergeant Seyboth waited at the Summit station until 3 p.m., when he became alarmed at the long absence of Cramer, and went out in search of him. He found him about a mile and a half from the summit in a famishing condition. His face was badly frozen and his eyes were actually frozen together. By the time Seyboth got him to the station on the summit his own nose and ears frozen, but he applied snow to the frozen parts and succeeded in saving them. Both are doing well. Another man at the lake cabin froze his feet severely the same day. A woodchopper, named J.P. Hawes, while chopping trees away from the trail on Pike's Peak, was seriously injured by his axe slipping and entering his ankle just above the instep, inflicting a deep wound.

The Perils of Peak Climbing – Morris' Adventure on the Best Known Mountain in America

Losing the Trail in a Blinding Snow Storm – Roosting on a Rock Over a Chasm 2,000 Feet Deep

Rescued at Last

Rocky Mountain News
August 20, 1874

Henry M. Morris, and not Morrison as printed by the dailies, is the name of the gentleman who, as already reported, so narrowly escaped a violent death on Pike's Peak, the latter part of last week, so far the accounts printed in the Denver newspapers have been both meagre [*sic*] and inaccurate. Not a single paper, in mentioning the adventure, has given the right name to begin with.

Mr. Morris, who with his invalid wife, had been stopping at Manitou for a few days, mounted a horse Thursday, and started alone to the peak expecting to return that evening. The ascent was made without accident, and he reached the tip top at noon, and telegraphed his wife an "all well." After taking in the sights, which from common report, are as marvelous as human eye ever gazed upon, and chatting awhile with the observers for the signal service, Mr. Morris started to descend to where his horse was hitched near timberline. Suddenly a huge black cloud which a few minutes before had been tumbling about to the westward, settled down around the peak, and the snow commenced to fall. Morris, fearing to stop lest he should be belated and prevented from reaching Manitou that evening and thinking he could soon get below the range of the storm, quickened his footsteps down the mountain. But the fall of snow increased, and the wind, strong at first, became a tempest, with a keen touch of winter in it. Morris, blinded by the snow, which beat against him in perfect clouds, nearly taking his breath, took the wrong trail, the one leading to the brink of the crater, a chasm second only to that of Yosemite. Reaching a pile of boulders, where the trail seemed to be lost, he commenced to clamber over them, when he slipped and rolled and dropped twenty-five feet, striking on a shelving rock, three feet wide and eight feet long. His head was gashed in two places, his body covered with bruises, and the blood poured freely from his wounds. He was stunned by

the fall, but, recovering his consciousness, but fearing to move, he bunched himself against the rock at his back, and awaited abatement of the storm. When the wind lowered and the snow ceased falling, and the sun shone again, Morris saw at a glance the awfulness of his situation. Above him, and on both sides of him, the rocks seemed almost perpendicular. Below him, just over the shelf upon which he lay, was a chasm two thousand feet deep, the sight of which appalled his senses, and he clung to the rocks with a sickening dread, as any human would.

Mr. Morris, however, is a man of calm judgment, and, as soon as he recovered from the first shock he decided to make the best of the situation, come what would. He divided his luncheon, consisting of sandwiches and cake, into nine parts, calculating to eat one part every day, and so prolong life at least nine days. He saw no one on the mountain that afternoon. A terrific wind and hail storm occurred. The wind chilled him to the marrow, and his suffering was intense. After the storm the hail-stones were four inches deep against his back. Taking from his pocket a bottle, from which whiskey had been spilled in the fall, he filled it with hail, and thus secured a small quantity of water. On Friday, about noon, he saw two men climbing a trail, and called to them with all his strength, but after listening a moment, they passed on, and disappeared behind a ledge of rocks. Those were the only persons he saw that day. The rocks at his back afforded him no shelter, and he was wet to the skin and very cold besides. He feared he might become delirious and jump off into that awful gorge. So all through Friday night he rubbed his legs and swung his arms about his head. He knew that to fall asleep was death.

Saturday morning about eight o'clock three men appeared on a point of rocks a short distance from where Morris was ailing. One of the men was Dick Templeman, a famous Pike's Peak guide, and the others were Spencer Harris and Rube Healy, residents of Manitou, and well acquainted with mountain trails. Dick Templeman, leader of the searching party, had left Manitou in the conviction that Morris would be found, if found at all, somewhere about the brink of the crater, as it is called. When Morris saw them he called to them. They heard him and answered. But his voice, instead of coming straight to them, split into a thousand echoes, and they were at a loss to locate him. Finally after a fruitless search with his eyes, Templeman hallooed to Morris to wave his handkerchief and to keep it in motion, and in this way his exact whereabouts was detected. Morris asked if they had a rope, and being answered that they did not, he despairingly threw up his hands, and in a low voice, which was but faintly conveyed to them in echoes said, "You can't save me without a rope." But they rescued him, nevertheless,

and without a rope, though only by the hardest. The men, with Templeman in the lead, worked their way down to within a few feet of Morris, and by the aid of his long linen coat, which he twisted and fastened under his arms, they succeeded in lifting and dragging him up over the precipice.

They helped him along to the trail, and led him to the back of a horse, and started down the mountain. Four times on the way down they lifted him off and let him sleep awhile. When brought to the Manitou hotel alive and as well as could be expected, there was a great commotion among the people, for nobody dreamed that he could survive two such nights as Thursday and Friday. Morris has been confined to his bed since Saturday, but he is doing nicely, and is expected soon in this city, where he is well and favorably known.

PART II

1875-1882

Up Pike's Peak

Denver Daily Times
August 2, 1875

Pike's Peak, Aug 2.—Hon. M.C. Kerr of Indiana, and Hon. Erastus Wells, of St. Louis, with a large party of friends, arrived at 8 a.m.; weather clear, thermometer, 36°.

Silver World

November 13, 1875

Pike's Peak has been climbed by 645 visitors this year.

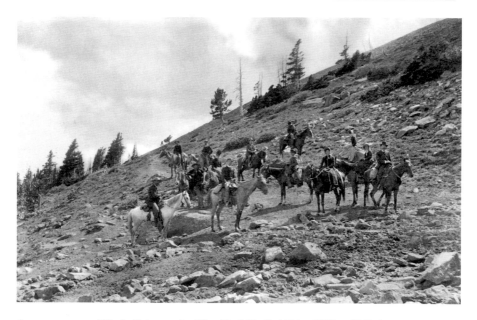

A party poses at Windy Point on the Pikes Peak Trail, 1880s. *William H. Jackson photo, Denver Public Library, Western History Collection.*

COLORADO MOUNTAINEER

September 20, 1876

On Monday there was a heavy fall of snow on Pike's Peak and surrounding mountains. The higher points of the mountain seldom present a whiter appearance than at this time, even during the winter.

COLORADO MOUNTAINEER

November 15, 1876

The Pike's Peak signal men have finished packing their supplies for the winter. It would astonish the natives to see how much it takes to keep those boys through a season. Two mules have been kept busy packing supplies for a month.

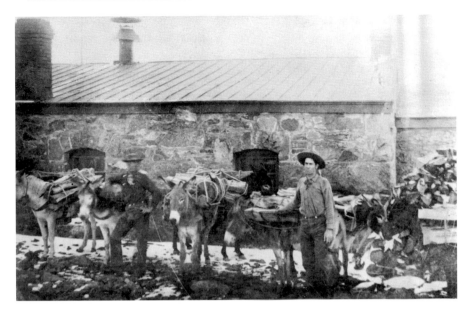

The Palsgrove brothers deliver wood to the Signal Station, circa 1870s. *Pikes Peak Library District.*

COLORADO MOUNTAINEER

November 22, 1876

There were 478 visitors to the summit of Pike's Peak from May 1st to November 18th.

Parties from the east are still ascending Pike's Peak. Last week a party went up who were from Kentucky. The trail is clear yet, but snow abounds on all sides after leaving the edge of timber line.

COLORADO MOUNTAINEER

December 20, 1876

There is very little snow visible on Pike's Peak for this time of year. The warm sun has melted off nearly all on this side of the mountain. The signal men say there is plenty on the trail, however, after leaving the Lake house.

COLORADO MOUNTAINEER

May 16, 1877

There is more snow on the trail to Pike's Peak than there has been at any time during the winter.

COLORADO MOUNTAINEER

June 6, 1877

The trail to Pike's Peak is clear as far as timber line, and snow is fast going from the summit. Greenwell of the signal service reports parties will have no trouble in riding to the station after this week. We believe no definite arrangements have yet been made for opening the Lake house, but Mr. Copley assured us last week that it will be opened for guests in a short time.

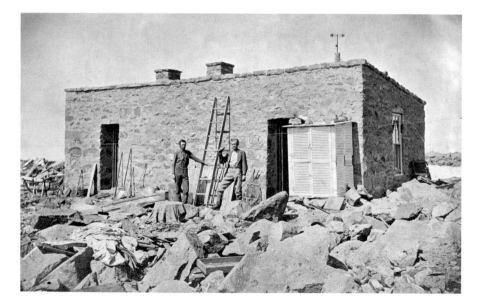

The U.S. Signal Station, built in the fall of 1873, and two signal corps observers. The ladder allowed rocks to be piled on the roof to keep it from blowing away in high winds. Photograph shows Albert James Myer (holding binoculars) and another man standing outside a stone observation station on Pikes Peak, Colorado. *Library of Congress.*

COLORADO MOUNTAINEER

June 20, 1877

The trail to Pike's Peak is now clear from snow, and parties can ride through to the signal station, on the summit.

COLORADO MOUNTAINEER

July 11, 1877

Sergeant Hobbs of the signal service, who has been stationed at Colorado Springs and Pike's Peak for the past sixteen months, has asked to be relieved, and received notice from the chief signal office at Washington a few days ago to close up his accounts and returns from this office and his relief would be forwarded. Mr. Hobbs has been a diligent officer in the discharge of his duty, often a difficult one, and now wishes to be placed on a station that does not present so many hardships as Pike's Peak.

COLORADO MOUNTAINEER

July 18, 1877

One hundred fifty-three arrivals at the summit of Pike's Peak this season up to last night.

COLORADO MOUNTAINEER

August 1, 1877

The gentleman who we mentioned last week as walking from the Cliff House in Manitou to the summit of Pike's Peak and return, was E.A. Whitney, of West Union, Iowa. The time was as follows: From the iron

spring to the summit of Pike's Peak, 5 hours and 40 minutes. From the summit to the iron spring, 3 hours and 5 minutes. He left the Cliff House at a quarter past five in the morning and returned to the house at a quarter past three in the afternoon.

COLORADO MOUNTAINEER

August 8, 1877

Mr. Greenwell came down from Pike's Peak yesterday and met on the trail 23 persons bound for the summit.

Among the number were Grace Greenwood and daughter. The travel to the Peak is far greater this year than ever heretofore.

MANITOU SPRINGS – PREPARING FOR THE SUMMER SEASON AT COLORADO'S FASHIONABLE RESORT

Rocky Mountain News
May 17, 1878

There are many improvements about this villa, but the most desirable is the new trail being built by the Manitou and Pike's Peak Toll Road Company. Legally authorized by charter, they are building a trail up through Iron Creek canon to the Lake House, where they intercept the government trail to the summit of Pike's Peak. By this trail parties on horseback will be enabled to make the round trip of twenty miles in one day. The scenery by this trail is said to be beyond description.

Colorado Springs Gazette

June 11, 1878

—The trail to the summit of Pike's Peak is now open and in good condition for travel.

—A party will leave at 7:30 this morning to make the ascent of Pike's Peak. They will be conducted by Messrs. Marsh & Brent, and will go via the burro line.

The Eclipse from Pike's Peak

Colorado Springs Gazette
August 3, 1878

The view of the eclipse of Monday from the summit of Pike's Peak—over 14,000 feet above level of the sea, and probably the highest point from which a total eclipse has ever been observed—is said by those who were fortunate to see it, to have been very fine and in some respects very remarkable. A gentleman who was one of the party from Manitou invited as the guests of Gen. Albert J. Myer, Chief Signal Officer of the army, to witness the eclipse from the signal station on the summit, has given us the following description of what he saw:

> *The sky was cloudless and the atmosphere wonderfully clear. The range of vision extended for probably 100 miles in every direction. The mountains north and west stood out clear cut against the sky, and the plains to the eastward stretched away until they seemed to mingle with the horizon. It is a rare occasion when distant objects can be so clearly and distinctly seen from the peak. There was no haze or mist to cloud the view in any direction. There was perhaps no special feature observable in the eclipse as noted from the summit, which could not be seen from any point on the plains below, except such as might arise from the clearness and rarity of the atmosphere incident to the elevation. This clearness and absence of moisture doubtless gave great advantages for scientific observation, and for the use of astronomical instruments.*
>
> *But there was no point probably within the entire limit of total obscuration which afforded such an opportunity for taking in at a single sweep of the eye such an extended area of the earth's surface.*

To the unscientific observer, the most remarkable phenomenon observable from the summit of the Peak was the approach of the shadow of totality from the north, in swift passage, and the sudden burst of sunlight which followed.

It must be remembered that the movement of the shadow from north to south was at the rate of about 30 miles per second…and it was necessary that one should have stretched beneath him a wide expanse of the earth's surface, in order that the eye could seize with a glance the line of the approaching shadow, and follow it as it rushed away southward. This advantage an observer who stood upon the Peak possessed.

Gen. Myers had very kindly advised our party where and how to look for the coming shadow, and we had taken our station on the northern edge of the summit several minutes before the period of total obscuration of the sun's disk. Without the aid of a glass the eye could at this time distinctly note the shimmering of the bright sunlight on the mountains more than 100 miles to the northward. Suddenly we observed them disappear and a great wall of darkness, stretching out on either side as far as the eye could reach, concealed them from us. With inconceivable rapidity the shadow swept towards us, its front a clear black line bordered with a fringe of yellow. It hid from the sight range after range of the more distant mountains and quickly covered with a ghastly pall the peaks and foot-hills and plains close beneath us.

When the shadow reached and enveloped us, the eye could dimly outline the nearer mountains, and could single out with strange distinctness the houses and farms in the valley below. The sky overhead seemed heavy and leaden, and every visible object was pallid and ghastly. The very shadow seemed tangible, and to weigh upon us, but the horizon all around was brightly illuminated by flashing rays of red and yellow lights like those of the Aurora. While we on the Peak were still enveloped in the depth of the shadow its upper line passed over the far-off range to the northward, and the clear sunlight struck the mountains, and away beyond and through the darkness they burst suddenly into view. In an instant other and nearer mountains appeared and then dimly shaded parks and the wooded Divide were bathed in sunlight, and the shadow rushed past us.

During the period of darkness the view around us was weird and terrible, but the sudden burst of sunlight which appeared upon the distant mountains as they seemed to spring up instantaneously from the bosom of the earth, was one of the most sublime and joyous visions that it is ever given to mortal eyes to witness. It brought a sense of relief and delight, and no one who saw it can forget it.

There was one peculiar phenomenon of color, connected with the approach and disappearance of the shadow of total obscuration which may have some scientific value, and be worthy of note. It was observed that along both lines of the shadow, and especially along its departing edge perhaps more distinctly than its advance line, there was a well-defined strip of yellow color, shading off into orange and light red. This appearance was well defined and bordered the dark lines like a fringe. These lines of color were noted by three or four persons who will agree as to their appearance. Will some scientist tell us why they were there and what they indicate?

ECLIPSE NOTES

At Pike's Peak, General Myer followed the corona for six minutes after totality. Prof. Langley saw the corona extending some six diameters from the sun on one side and twelve diameters on the other. The corona resembled the zodiacal light.

SILVER WORLD

September 21, 1878

It is proposed to construct a promenade around the summit of Pike's Peak.

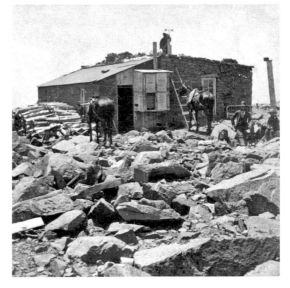

On the trail to Pikes Peak from Bear Creek Canon to the summit, fourteen miles; U.S. Signal Station, 14,336 feet. *Photo by Eugene Brandt (between 1870 and 1876), Library of Congress.*

AN ASCENT OF PIKES PEAK, 1879

Henry L. Stearns, Appalachia Magazine
Published June 1882

Leaving the Manitou House at nine o'clock in the morning of the 12th of June, 1879, I took the road leading south. About a quarter of a mile from the hotel, the road divides. The right-hand branch, leading southwest up the Ute Pass, is the old Leadville road. The left hand road leads southeast to the Iron Ute Spring and the Pike's Peak Trail. On this road, by the side of which runs a roaring mountain stream, is the fountainhead of the Manitou and Colorado Springs Water Works, about half a mile from the Iron Springs.

On reaching the spring I refreshed myself with a draught of its invigorating water, and went on. Here the road crosses a little rustic bridge, and narrows down to the trail, following the right-hand side of a most beautiful canon, with tall pine trees, scrub-oaks, rocks, and a great profusion of mountain yuccas. These grow two feet high, with narrow leaves, which are very stiff and sharp-pointed, which has given rise to the name Spanish Bayonet. The flower is a very pale straw-color. The ascent begins in this canon, and I soon heard the stream roaring below me, though not very far, for the trail is not steep here.

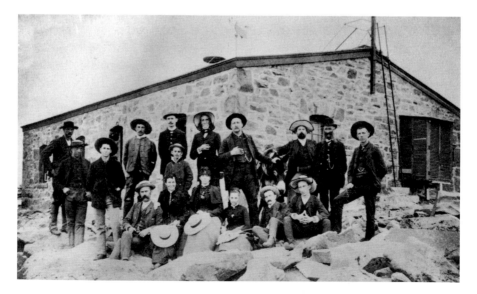

"Tenderfeet," including one burro, who rode up from Manitou. Guide John Palsgrove is on the far left. At the far right is J.R. Ramsey, "who was in charge of the station," August 5, 1885. *Pikes Peak Library District.*

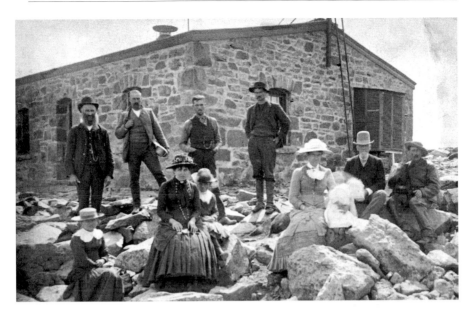

Colorado Springs Tourists on Pikes Peak Summit, August 21, 1885. Party includes the first baby brought up on horseback, Ruth Richards, aged two years, being held by her mother, Mrs. William Richards (in white hat). *History Colorado.*

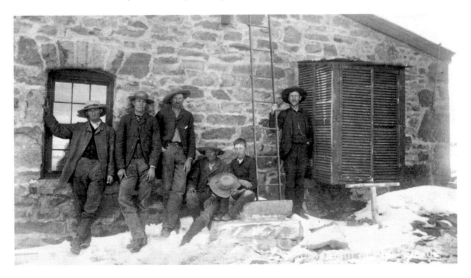

Pikes Peak summit party, June 28, 1887. *Pikes Peak Library District.*

About half a mile from the Iron Spring one comes to the toll tent, where a man camps out from the middle of May to the middle of October. His duty is to collect toll from those who ascend the Peak,—twenty-five cents

for a man on foot, and one dollar for a man on horseback. This money goes towards keeping the trail in repair.

After leaving the toll tent, I descended a little hill and crossed the stream on a picturesque bridge to the left-hand side of the canon. Here the ascent begins in earnest, and it proved to be very steep and hard. The trail mounts higher and higher until the sound of rushing water grows almost inaudible, and one can look down on the tops of tall trees and rough, jagged rocks far below. As I turned a corner, a large rock appeared, which looked as if it was an impassable barrier to my further progress; but on reaching it I found that the trail turned sharply to the left and passed between two huge bowlders [*sic*], over a very small bridge. Here a little brook, a tributary of the main stream, issues from underneath one of the bowlders, clear as a crystal and very cool. A little cup was placed here for the use of thirsty travellers.

I lingered here a few minutes, not so much to rest as to admire the wondrous beauty and sublimity of the place. The two immense rocks with the little trail between them, the crystal brook gushing out from their feet, and the rustic bridge shaded by tall pine trees, with here and there a scrub-oak and a yucca, formed a scene which could not be forgotten. On one side the mountain wall rose steep above me, and on the other was the deep canon, with tall, ragged mountains opposite. This is known as Naiad's Grotto. I was somewhat loathe [*sic*] to leave this place; but I must be getting on, so, after one more look all around, I continued the ascent. The trail was now a little more rough and precipitous than before. After going some distance further, I came to Sheltered Falls, half-way between Manitou and the Lake House. A large bowlder juts out over the stream, under which the water rushes and falls in a sheet for a distance of about twenty feet, then breaks up into numerous little rapids. It is a most beautiful sight. The trail crosses a bridge at this place, to the right-hand side of the canon. Standing on the bridge, one looks down the canon, over the tops of all the trees and some of the mountains,—over Manitou and the Garden of the Gods, and out over the prairie beyond. Cathedral Rock, in the Garden, looked strikingly grand from this point, standing high above everything else there. After enjoying this sublime view for some time, I started on again, and soon reached the Devil's Gap, which is a narrow passage between two immense bowlders, and, underneath, another and still larger one, which looks as if it would tumble over at any moment. The trail descends a little here, and passes through a considerable tract of coarse red gravel. This is on the steep side of the mountain, and is a dreary looking place. Passing this, I came to Rosemma Falls, and Little Minnehaha Falls, not far beyond. Farther on was a group of large round rocks, which

are called Pebbles from Pike's Peak. These "pebbles" would not be easy to carry away in one's pocket. The trail now descends for some distance until it comes to the stream. Here the water is so shallow that there is no bridge, and the only crossing, on foot, is by an old dead trunk of a tree which lies across the stream. I sat down on this tree to rest, it being just twelve o' clock.

This is a dark and shady spot, with tall pine trees and cavernous-looking rocks. Indeed a timid person would easily imagine these dark and shadowy places to be the lairs of wild animals, and certainly with reason. When one is alone in such a wild and gloomy spot, there is enough to excite the imagination, not to say fear. Though not afraid, I kept a good watch all around while I remained there. Bears, wild-cats, and Rocky Mountain lions are sometimes met on this trail. The "lion" is said to be as large as a small calf. They are quite savage if anything crosses their path, and doubtless if I had met one and attempted to pass him, he would have questioned my right of way. A bear or a wild-cat might or might not have run from me. I was most fortunate in not meeting any of these creatures, as, having only a five-shot revolver, of .32 calibre, I was poorly prepared for them. Mountain wolves are also to be met with on the summit, and often come around the station for any scraps of food that are thrown out. A small badger was the only animal I saw.

After resting and lunching, which occupied half an hour, I started on again, and passing through more of these dark, wild places, soon came to a grove of yellow birches, all young trees, varying in diameter from one to three inches, and from twelve to fifteen feet in height. They were growing so thickly that it was not possible to get through them, except on the trail. All the old trees had died and fallen, and their white trunks lay thickly scattered on the ground among the young growth. The trail is comparatively level here for nearly a mile—which was a pleasant relief after so much steep climbing—and I walked leisurely along, enjoying the sight of this grove, and was sorry when, at last, I came to the end of it.

Crossing the stream again, this time on stepping-stones, I came to the foot of a very steep, rocky, and desolate hill, which is the last one before reaching the Lake House, and the hardest to climb. There is more dead than living wood here, as it is only one thousand feet below timber line. Huge dead trunks lie thickly strewn over the rocks, looking ghastly enough as they gleam in the sunlight, some of them so gnarled and twisted that they look like gigantic serpents. The silence was really oppressive, and, to break it, I fired my revolver; but the report, echoing round the mountains, only increased the dreary sense of loneliness. After an hour of hard, painful climbing, stopping

every few steps to rest on some old, dead trunk, I reached the top of the hill, and kept on down the other side, by a rough and circuitous trail, to the Lake House, which is just at the foot of the hill, by the side of a beautiful lake which covers about four acres and is thirty feet deep.

This Lake House is a little more than half-way between Manitou and the summit. It is a log-cabin of one story, with a flat roof, and contains six rooms, three of them sleeping-rooms for guests. The telegraph wire, which goes to the signal-station on the summit, is connected with an instrument in the office here, and then connects with the station in Colorado Springs, fifteen miles below. A rough log-shed, occupied by horse and a donkey (or burro), is the only other building, besides the hotel, in this place, which is 10,800 feet above sea-level, 4,676 feet above Manitou, and 3,536 feet below the signal-station at the Peak.

As one approaches the house, the great snow-crowned peak comes into full view, rising majestically, giant among the pygmies, with first a growth of tall pine trees, thickly interspersed with dead trunks, some standing and others lying on the ground, reaching about one third of the way up,—then a bare brown space, and lastly the snow, relieved here and there by naked rocks.

Passing the night at the Lake House, where, even at this altitude, mosquitos and flies exercise their tyranny over the weary traveller, I proceeded on my way early in the morning on horseback. A son of the proprietor accompanied me, to take care of the horse and ride him back. It was four o'clock when we started and the air was cold. How desolate everything looked in the gray morning light. The trail led over the crest of the hill for some distance, then turned to the right, up the rocky side of the mountain and among the trees. The telegraph wire follows this trail, and is fastened to the trees as far as timber line,—then to rocks, and lastly to short poles secured in the snow by piling stones around their bases.

About half-way up to the timber line we saw the sun rise, and it was a sight which alone was worth this toilsome expedition. It was a most beautiful morning, and as the sun rose it gilded the mountain tops, while the sky overhead was one vast expanse of cloudless azure.

Reaching the snow line—which this season is about 500 yards beyond the limit of timber growth—at 5-30 A.M., I took leave of my companion and his horse. I watched them until they disappeared among the trees, then commenced the rest of the ascent on foot. I looked around on the dreary waste of rocks and snow, stretching far above me, with nothing save the telegraph wire to guide my footsteps; while below me was the whole Rocky

Mountain Range, the tallest of which I could look down upon. A dread sense of loneliness came over me, and for a moment I was almost overpowered by it. Conquering it, however, I began my ascent. This was by no means easy, on account of the light air, which made respiration so difficult that only the slowest progress was possible.

Concluding that the telegraph wire was erected in the safest places, and knowing that it was a sure guide, I followed it. The air was cold and the snow was frozen hard, which was fortunate, as otherwise the ascent would have been still more difficult, if not impossible. In some places the snow was from fifteen to twenty feet in depth.

The sky at this altitude is of a most intense blue, much more so than it appears at sea-level, or even at Manitou, 6,124 feet above the sea. It was a most beautiful sight,—perfectly clear, with the exception of one small cloud which hung over the extreme summit of the mountain, completely veiling it. As the sun rose higher, this cloud disappeared.

At last, after three and a half hours toiling over the rocks and snow, I came to the signal-station, which is on the highest point of the summit, 14,336 feet above sea-level. Here the observer, Private J.K. Sweeney, U.S. Signal Corps, gave me a kindly welcome. I was much too exhausted to do anything but sit down by the fire, and soon after, feeling no better, lay down on the bed and staid [sic] there nearly all day. It was a great disappointment to me to be so used up, as I could not take such an interest in the instruments and outside scenery as I would otherwise have done.

Toward evening, however, I felt able to take a walk around the summit with Mr. Sweeney. The sky was beautifully clear, and the view magnificent. To the west lay the Snowy Range, 150 miles away, and to the south, the Spanish Peaks, 200 miles, while to the east the vast level prairie stretched away until it met the sky. To the north was the Rocky Mountain Range,—of which Pike's Peak is a part,—with Long's peak, the next highest eminence, 14,300 feet in height. This is about as far north of Denver, as Pike's Peak is to the south. On the southwest side of the summit is a steep gully, almost perpendicular in some places, which extends down to South Park. We amused ourselves for a short time by rolling rocks down the steepest part, to hear the reverberation. The momentum attained was so great that they went through a large snow drift, which lay in their way, without the slightest apparent check to their speed, finally to be dashed to pieces against some invisible obstacle far below. The crash was distinctly audible, as well as the low rumbling which preceded it. A large rock was sent down directly after one somewhat smaller, overtook the lesser one and sent it flying into fragments.

This amusement came near ending in a tragedy. The observer had stepped on a bowlder which overhung the precipice, in order to loosen a large, round stone, when I noticed a slight movement of the rocks and spoke to him just in time. He jumped upon the firm rocks, and the next minute down went the bowlder with a number of other stones, great and small, crushing, tearing, rolling, shivering to atoms, on their way; and finally came the thunder at the bottom of the gully. We remained for some minutes speechless, thinking of what might have happened.

On our way to the station another accident threatened, this time to me. Passing over a soft snowdrift, I suddenly sank to the waist, and, had I been alone, would in all probability have staid there, as one of my feet was caught between some rocks. My companion, who was on firmer footing, pulled me out by my shoulders. Hardly had we reached the building when there came up a blinding snow squall, which, however, did not last very long. It reduced the temperature from 35° to 29°, only six degrees, but it seemed a great change. The anemometer showed that the wind was blowing at the rate of twenty miles an hour, and the barometer marked 17.871 inches, which at sea-level 30.081 inches, the difference being 12.210 inches at that height above the sea.

As the squall cleared off, the sun came out in a blaze of glory just before it set and gilded the tops of the mountains, which stood out in bold contrast to the sombre [*sic*] valleys. One has no true idea of the height of Pike's Peak until he stands on the summit and looks down, and this sunset seemed to me the best time to realize it.

We spent the evening looking over the records, the observer very kindly explaining to me what I did not understand about them. The cold wind was howling outside, but it was warm and cheerful within, and the place did not seem so very lonely until we had retired and the light was out. Mr. Sweeney was soon asleep, but I,—unaccustomed to the light air, together with the excitement and fatigue of the day—was not able to sleep for some time, and fully realized the extreme desolation. The moaning sound of the anemometer, as it whirled outside on the roof, greatly added to my loneliness.

In the morning I bade adieu to my friend (as he had proved himself to be by many acts of kindness) and started down the mountain,—with the same guide as on the ascent, the telegraph wire,—soon reaching the "jack-straw region," a most appropriate name for this confused mass of dead timber. The air was cold; the temperature had fallen in the night to 20°, and when I left the station it was 26°, with the wind blowing at sixteen miles an hour, and the barometer standing at 17.871 inches. Soon, however, a warmer

climate and heavier air was reached at the Lake House, where dinner and rest occupied four hours.

Setting out again much refreshed, I walked rapidly down the trail, not stopping until I reached the toll tent. Resting here about half an hour, I again started for Manitou, pausing only at the Iron Spring for a drink of its water, and reached the Manitou House where I received a cordial welcome.

ROCKY MOUNTAIN SUN

November 19, 1881

During a 36-hour snow storm on Pike's Peak last week, the wind averaged fifty miles an hour, and four out of seven burros engaged in transporting wood to the Peak were frozen to death near the site of the old Lake house.

ELECTRICITY ON PIKE'S PEAK

Nature Magazine
July 13, 1882

The following extracts relative to electricity, from *Pike's Peak Monthly Abstract Journals*, have been very kindly forwarded to us by General Hazen, the chief of U.S. Signal Service, in accordance with a request made by us; we believe their publication will prove useful:

November 23, 1873.—Atmospheric electricity manifested itself when line was broken by a crackling sound when binding screws were touched, and bright sparks drawn when stovepipe was touched by fingers.

December 7, 1873.—While line was broken I heard relay working; thinking line had been repaired, I hastened to adjust; received a severe shock, which convinced me that something stronger than our battery had charged the wire. Instrument cut out and lightning arrester [mechanism consisting largely of two metal plates placed a few inches apart that intercept and divert damaging electrical currents on the telegraph line away from delicate equipment] screwed closer; in a few minutes a continuous stream of electricity passed between

The Spartan Signal Station interior—desk, snowshoes and guitar—July 1889. *Pikes Peak Library District.*

the two plates of the arrester with a loud noise, resembling that produced by a child's rattle; the fluid passed not in sparks, but in five or six continuous streams of light, as thick as a pencil lead, for two or three minutes at a time, with short intervals between; this continued for over an hour.

December 11, 1873.—On retiring I accidentally touched my drawers with two fingers of my hand, and drew two sparks from them. This is a common phenomenon after a snow-storm.

January 12, 1874.—Electric shocks.

January 24, 1874.—Received electric shock when opening stove door; as usual, it was not repeated.

February 25, 1874.—Same as January 24.

May 11, 1874.—During the entire day severe shocks were felt by any one touching the wire, and, the line being open, I could make plain signals with the key for about ten minutes.

May 20, 1874.—p.m., report could not be sent on account of atmospheric electricity (a thunder-storm).

May 21, 1874.—A flash of fire about two feet long leaped from the arrester into the office, illuminating the rooms.

May 24, 1874.—A heavy thunder-storm passed slowly and directly over the peak; large sparks passed constantly through the arrester, while a strange

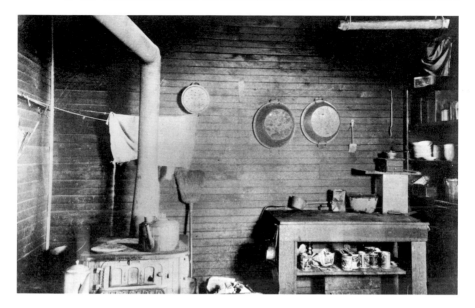

The Signal Station kitchen, July 1889. *Pikes Peak Library District.*

crackling of the snow could be heard at times. While making the 2 p.m. observation, I heard the snow crackle as above mentioned, and felt at the same time on both temples, directly below the brass buttons of my cap, a pain as if from a slight burn. Putting up my hands, there was a sharp crack and all pain had disappeared.

May 29, 1874.—At 6.20 a terrific storm commenced; blinding flashes of fire came into the bath-rooms from the lightning arrester and stoves; loud reports followed in rapid succession.

July 1, 1874.—A party of visitors were caught in a thunder-storm not far from the summit, and all state that they experienced peculiar burning sensations on face and hands, and heard a hissing sound proceeding from hair and whiskers.

July 9, 1874.—Heavy thunder-storm; large sparks passed through the arrester during its continuance. Mr. Copley telegraphed me this forenoon that he twice got knocked down, while repairing the line, by electric shocks.

July 14, 1874.—Thunder-storm; lightning in beginning very severe. I received a very painful shock while working over the line by my fingers accidentally touching the metal of the key.

July 15, 1874.—Thunder heard in the distance throughout the evening, while strong ground currents passed through the arrester.

July 16, 1874.—Severe thunder-storm; sharp flashes and retorts came through the arrester to the terror of several lady visitors. Outside the

building the electrical effects were still more startling. The strange crackling of the hail mentioned before was again heard, and at the same time my whiskers became strongly electrified and repellant, and gave quite audible hissing sounds. In spite of the cap I wore my scalp appeared to be pricked with hundreds of red hot needles, and a burning sensation was felt on hands and feet; several of the visitors who were outside had the same experience. A large dog who had followed his master out-doors became terrified, and made for the door with a pitiful howl. Lightning was seen in all directions in the evening, and ground currents passed incessantly through the arrester.

July 19, 1874.—A severe thunder-storm passed close over the Peak between 1.30 and 2.30 p.m.; lightning struck wire between 2nd and 3rd poles from the house; for a moment wire resembled a rope of fire and vibrated violently for some minutes after the discharge—no damage done. Frequent loud discharges took place along the ground-wire between it and the rocks on which it rests. Hair and whiskers of anyone outdoors were electrified by each discharge.

July 21, 1874.—Heaviest thunder-storm of the season today; lightning terrific; constant crackling of fallen hail and peculiar clattering of rocks as if shaken by subterranean convulsions, indicated the highly electrified state of the summit.

August 2, 1874.—I was obliged to keep the telegraph instruments cut out during the greater part of the day.

August 3, 1874.—The lightning rendered the line almost useless the entire afternoon; I got severely shocked when sending my report.

August 13, 1874.—Seventeen visitors to day; some of them made ascent during a severe thunder-storm, and were much alarmed by the effects of the electricity upon their hair, one of them declared that his hair stood up so stiffly as to lift his hat!

October 5, 1874.—Severe thunderstorm below summit in afternoon, observers severely shocked whilst calling Fenton at lower station.

May 22, 1875.—During storms to-day (hail and snow) electrical quite strong.

May 23, 1875.—Electricity strong at intervals during day and night.

May 24, 1875.—Hail from 3.55 p.m. till midnight, accompanied by very strong electricity, decreasing and increasing in intensity, a notable fact in all hail-storms.

May 25, 1875.—Electricity has shown itself nearly all day with variable force (hail frequent during the day).

May 29, 1875.—Hail about midday accompanied by electricity. In all our hailstorms the fall of hail entirely ceases for about a half a minute, following a heavy electric discharge, and the hail fall is considerably heavier for some time following the discharge than before.

July 5, 1875.—Terrible electric storm in the afternoon, at first its effects were felt only by the line, but about 2 p.m. its presence was evident everywhere on the summit; a constant stream of flame from the arrester; a constant crackling noise heard out of doors as though made by small pistols.

May 11, 1876.—During hail-storm at 7.30 I was compelled to cut out the wires owing to their intensity, this I attempted with ungloved hand, and learned a lesson that was an impressive one; luckily I escaped with a slightly bruised head and a fearful scare.

May 25, 1876.—During a thunderstorm the wire outside, at two or three places, kept up a peculiar singing noise, resembling the singing cricket. I have previously noticed that the singing noise is never heard except when the atmosphere is very damp, and rain, hail, or snow is falling.

June 16, 1876.—At 5.20 p.m., as I was sitting on a rock near the monument, on the eastern edge of the summit, a blinding flash of lightning darted from a cloud seemingly not more than 500 feet north-east of me, and was accompanied by a sharp, quick, deafening report, and at the same I felt the electricity dart through my entire person, jerking my extremities together as though by a most violent convulsion, and leaving tingling sensations in them for a quarter of an hour afterwards. Straine, who was sawing wood in the shed at the time received a similarly violent shock, and says that a ball of lightning appeared to pass through the store-room and wood-shed in which he was working, leaving behind a strong sulphurous [*sic*] smell.

July 13, 1876.—Singing on the wire. It also seemed to come from the instrument shelter and the house, as well as from the wire. Thunder loud and continuous during the afternoon.

July 23, 1876.—The anemometer stopped working on account of the electric storms. Private Straine and O'Keefe were shocked while trying to fix it, so they had to give it up until the storm had subsided somewhat.

August 18, 1876.—A beautiful phenomenon was observed by myself, Private Greenwell, and four visitors. The peculiar singing noise (or sizzling noise) was heard again, always before in day, but this time at night, but the line for an eighth of a mile was distinctly outlined in brilliant light which was thrown out by the wire in beautiful scintillations. Near us we could observe these little jets of flame very plainly. They were invariably in the shape of a quadrant, and the rays concentrated at the surface of the line in a small mass about the size of a currant, which had a bluish tinge. These little quadrants of light were constantly jumping from one point of the line to another, now pointing in one direction then in another. There was no heat to this light, and when I touched the wire I could only feel the slightest tingling sensation. Not

only was the wire outlined in this manner, but every exposed metallic point and surface was similarly tipped or covered. The cups of the anemometer appeared as four balls of fire revolving slowly round a common centre. The wind vane was outlined with the same phosphorescent light, and one of the visitors was very much alarmed by sparks, which were plainly visible in his hair, though none appeared in ours. At the time of this phenomena snow was falling.

March 27, 1877.—Singing noise heard upon the wire today.

May 12, 1877.—Hailstorm, accompanied by intense electricity.

May 24, 1877.—Sergeant Hobbs and Private Greenwell received severe shocks during the day.

August 6, 1877.—Intense electricity; all metal objects were tipped with sparks.

November 25, 1877.—Snow-storm all day attended by intense electricity, which could be heard crackling in a person's hair continuously, although no reports of thunder were heard.

December 26, 1877.—The atmospheric electricity was very intense during the day, and at times would crackle on various objects in the room.

January 25, 1878.—Several thunderstorms occurred in the surrounding parks and gulches. The electricity on the summit was very intense, causing a continuous snapping of the lightning arrester.

May 12, 1878.—A snow-storm commenced during the night, and at 1 p.m. was drifting furiously by a rising gale. The electricity varied with wind—gusts, and was so intense at times as to render our position exceedingly dangerous. The telegraph wires were cut out, but violent sparks would still jump six inches between the disconnected *windows*. One violent discharge seemed to have occurred in the chimney, for a terrible commotion was caused in the soot and ashes.

May 24, 1878.—At 8 p.m. snow commenced, attended with severe electricity, lasting for an hour. The wires had to be cut out and parted, and a vivid glaring was continuous in the windows. A lamp set in the north window would, with its flame, cast a shadow on the opposite wall for several seconds.

July 1, 1878.—During afternoon sleet fell, accompanied by intense electricity. At 3.20 a violent explosion occurred in the room, near the stove, scattering wood and knocking down the stove-pipe.

April 10, 1879.—The telegraph wire heavily charged with a ground current of electricity this evening, and it was with difficulty that the signal was transmitted. The current at times was entirely reversed.

June 16, 1879.—Light sleet, accompanied by thunder. Only a few peals were heard when it gave way to a strong steady current over the wire, and for

twenty minutes one of those electric storms peculiar and common to Pike's Peak prevailed. A queer hissing sound from the telegraph line, the wind-vane post, and other posts, standing in a deep snow-drift near by. I stepped out to view the phenomenon, but was not standing in the snow-drift long, when the same buzz started from the top of my head, my hair became restless, and feeling a strange creeping sensation all over my body, I made quick steps to the station; once inside upon the dry floor, the effects soon left me. After getting inside I opened the telegraph key, and found a continuous bright spark passing between the key and the anvil, even when they were separated one-eighth of an inch; and by putting two thicknesses of writing-paper in this space, it was scorched, and perforated by numerous burnt holes. By accident I completed the circuit with both hands, when I received a shock that sent me back on the floor.

June 29, 1879.—Thunder-storm (very severe), 11.10 to 11.30 a.m., during which time a bolt passed the arrester with a report exceeding that of a rifle, and threw sparks all over the office. The suddenness and violence of the shock stunned me, so that it was a little while before I could realise [*sic*] what had happened.

August 11, 1879.—During passage of a thunder-storm over the Peak, a great amount of atmospheric electricity was manifested.

August 12, 1879.—Heavy snow and sleet began falling at 5.30 p.m.; at 5.40 a ball of lightning went through the arrester with the report of a rifle, throwing a ball of fire across the room against the stove and tin sheathing; the wood-packers, Messrs. Wade and McDonald, had taken refuge in the station for a few minutes, but concluded immediately that this was rather an uncomfortable place during a storm, and left immediately; their dog however was far in advance of them in seeking shelter outside. Mr. Wade declared that the lightning struck him in his feet and legs. At 6 p.m. the lightning struck the wire and building at the north end, where the wires come through the window and arrester with a crash equal to any 40-pounder. It burned every one of the four wires coming in at the window into small pieces, throwing them with great force in every direction, and filled the room with smoke from the gutta-percha insulation; the window-sash was splintered on the outside, one pane of glass broken, and another coated with melted copper. The anemometer wires were also burned up and the dial of the anemometer burned and blown to pieces. Private Sweeny was about deaf for some time afterwards. One piece of the wire was thrown with such force that when it struck the barometer three feet distant it was wound around it, without, however, doing any damage to the barometer.

July 2, 1880.—Line worked poorly on account of storm, each flash of lightning causing the instrument to be thrown out of adjustment; the signals at midnight were got off with great difficulty.

July 19, 1880.—Atmospheric electricity quite prevalent during the evening.

July 21, 1880.—Hail in afternoon and night, accompanied by heavy flashes of lightning which played around the arrester, and exploded with great force.

July 23, 1880.—Hail, rain and snow during the day; ended at 5.40 p.m. Intense ground currents during prevalence of storm.

June 23, 1881.—A light fall of hail, accompanied by terrific flashes of lightning, which snapped on the lightning arrester, and exploded with great violence.

July 4, 1881.—During the progress of the rain-storm it was accompanied by the heaviest discharges of lightning and thunder that I ever witnessed in all my experience at this station. The lightning snapped on the arrester and exploded with great violence in the office. Several times during the evening I was certain that the station building would be struck and demolished, as the lightning was almost continuous.

August 21, 1881.—Heavy hail began falling at 12.30 p.m., continued at intervals until 4.15 p.m., when it ceased. The hail was accompanied with the heaviest discharge of lightning that I ever witnessed in all my experience at this station. It was impossible to remain in the office during the progress of the hailstorm, as the lightning was almost continuous, and snapped and exploded in all directions, so that I was compelled to retreat to the kitchen for safety. The south-west portion of the station-building was struck by lightning, but no damage of any consequence was done, nor was the station-building impaired by the shock. The lightning arrester and ground wires were badly damaged, but the worst feature of the storms was the fact that both the station and extra barometers were also struck, and the cisterns of both cracked.

During the storm a shepherd was killed by lightning, and when found was stripped of his clothing and boots; he had taken refuge under a tree.

SCIENTIFIC AMERICAN

July 8, 1882
Reprinted from the Colorado Springs Republican

Signal Officer L.M. Dey writes of further electrical phenomena on the summit:

In placing my hands over the revolving cups of the anemometer—where the electrical excitement was abundant—not the slightest sensation of heat was discovered, but my hands instantly became aflame. On raising them and spreading my fingers, each of them became tipped with one or more beautiful cones of light, nearly three inches in length. The flames issued from my fingers with a rushing noise…accompanied by a crackling sound. There was a feeling as of a current of vapor escaping, with a slight tingling sensation. The wristband of my woolen shirt, as soon as it became dampened, formed a fiery ring around my arm, while my mustache was lighted up so as to make a veritable lantern of my face. The phenomenon was preceded by lightning and thunder, and was accompanied by a dense driving snow, and disappeared suddenly at 8:55 o'clock, simultaneously with the cessation of the snow. I much regret that there was no one on the Peak to witness the phenomenon with me—it was a wondrously beautiful sight.

PART III

1883-1891

In Search of a Round-up

A Lady's Experiences in the Wild West in 1883
by Rose Pender

The railway terminates at Manitou, and there, on a delicious evening, we got out. It had rained nearly ever since we left Cheyenne, but at Manitou it was a warm balmy rain that brought all the flowers and leaves bursting into bloom, and very pretty everything looked. Our hotel stood amongst trees, and looked across the valley towards the Garden of the Gods. Pike's Peak, on the other extremity, stands out in snowy relief from the dark pine forest that dots its feet.

Snow had fallen heavily a few days before, but only on the highest hills. I forget the name of our hotel, which is very ungrateful of me, as it was quite one of the nicest we had met with. We had wired for rooms, and found they had everything very nice for us, and even a fire in my bed room—a real luxury, and very unusual in this land of stoves. The dinner was excellent, and we afterwards wandered through the village for about a mile and a half, as far as a noted spring of mineral water. I delighted in the sweetness of the spring flowers, just beginning to peep out here and there.

We had made the acquaintance of a very pleasant English couple on their way home from China; we had been fellow travellers off and on some time. They were very anxious to make the ascent of Pike's Peak the next morning,

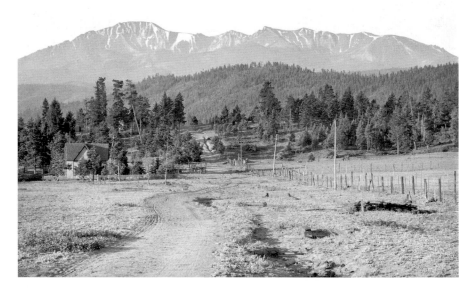

Pikes Peak from the north, at the Woodland Park Railway stop, circa 1900. *Denver Public Library, Western History Collection.*

and begged us to go also. I did not really care about it. It looked so cold and so terribly high up, and I was not prepared for mountain climbing, having neither strong boots nor a rough dress with me. However, as all our party were quite inclined to go I gave way. We were to start at six the next morning, and were to ride to snow-line and then betake ourselves to our feet. I went to bed early and dreamed of Itta and Dolly struggling up Mount Blanc, and that I was vainly trying to overtake them.

Shortly after 5 o'clock we were up and preparing for the expedition. I wore a striped skirt of chintz, and my Norfolk jacket over a flannel shirt. My boots, an old pair of patent leather ones, worn for comfort in our long railway journeys, were extremely unfit for rough walking. In a very broad-brimmed hat and my thick veil, I fancy I looked the British tourist, as depicted by *Punch*, to the life. Mr. B--- would insist on wearing a Scotch cap, in spite of our remonstrances. As the glare of the sun on the snow would be great, and good head-covering indispensable, J--- took the precaution of carrying a large silk bandana; he had climbed Swiss mountains before, and knew what to expect. Oh, I must not forget my umbrella, a faithful companion, from which I never separated.

Our steeds and guides waited at the Piazza; I chose a nice little black mule in preference to the peculiar three-cornered ponies. It was a lovely road,

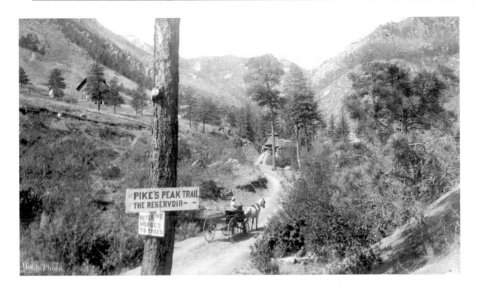

A carriage on the way to Pikes Peak, circa 1880s. *Denver Public Library, Western History Collection.*

or rather path, winding ever higher and higher through pine woods, here and there interspersed with an open common, covered with sweet-smelling flowering bushes. There were bears and leopards to be found, our guide told us, and in the winter they became quite daring, and would prowl round the village at night in the hope of picking up a stray child—or something.

The higher we got the rougher grew the pathway. Big stones and rocks rolled from under the animals' feet; they slipped and plunged along, always excepting my little black mule. She seemed to have the feet of a cat. I gave her her own way entirely, and to the art with which she climbed over or up the hillside to avoid obstacles was truly wonderful. A large tree had fallen quite across the path at an awkward place. The men got off and led the horses, but my mule considered a moment, then bucked her fore-legs over and scrambling her hind-legs in some wonderful manner she got over quite safely and went placidly on. By the time we reached snow-line most of the party, including our English acquaintances, had had enough of it. It certainly did look a formidable undertaking, and the guides were loud in their protests that we should not be able to get to the top, the snow was so deep. Some breakfast had been sent from the hotel, and this was then spread out. I declined to partake, feeling that I should require all my breath and agility if I was ever to reach the Observatory, but I wrapped up a biscuit and a piece of cheese and pocketed them, and secured a small flask of brandy.

Seeing we were determined, the guides then proceeded to fasten gunny-sacks to our feet. In reality they only tied them up in matting half-way to the knee, and they had not even brought matting enough, so sure were they that the snow-line would be the limit of the expedition. There were only five of us after all: J----, Mr. B----, myself, and two Americans, one from New York and the other, I think, a Brazilian. Our first climb was very severe, and nearly stopped our breath; but after a bit we got better, and went along at a good pace, till we reached the last crown of the Peak. The snow was very deep and not hard, and often I slipped through up to my waist, struggling out as best I could. The sun was scorching, and I felt grateful for my thick veil and the handkerchief round my neck. The umbrella had to be closed, as it was impossible to scramble along holding it up.

Mr. B--- kept well ahead, the rest of us together in straggling fashion. The guide was of no help to any one, and at last threw himself down and declared he was done. I must tell you that he had remained behind and eaten his luncheon, fully convinced that we should all come back; but finding we did not he had to hurry to overtake us. Fortunately we had the brandy; and a good dose of it had the desired effect, and enabled him to get along. Presently the Brazilian sat down and declared himself faint with hunger. He had eaten no second breakfast. Some brandy and my biscuit and piece of cheese restore him, and on we went. When not more than a quarter of a mile from the longed-for top I began to feel "done." My breath came in sobs—my feet felt like iron, and a terrible pain at my chest warned me to persevere all I knew. The telegraph wires now showed us the route, the poles half-way in the snow. I resolved to go from one to another without stopping. Alas! I had to stop twice, and now the guide and the Brazilian collared me, passed me, and to my bitter mortification, reached the door of the Observatory quite ten yards ahead! It was no use, I could get on no faster. I fancy we appeared forlorn objects to the two clerks who, poor souls, lived up at the top. It is the highest Observatory in the world, and the forecasts of the weather are taken from the top of Pike's Peak, one of the highest mountains in North America, 14,420 feet above the sea.

As to the view, I cannot describe it; it was wonderful! They said we could see for 150 miles over the Rockies—quite into Arizona, and I can believe this was so. One peculiarity of it all was the striking clearness of everything. We could see Denver City, and even beyond, whilst Manitou, the Garden of the Gods, and all the weird scenery looked as plain as if we were there. The colouring was splendid. No words of mine can give the least idea of the glory of it all.

Our hosts hurried to make us some hot coffee, and to prepare us a meal; but we could not eat. The air affected us all more or less. I felt faint and painfully overcome with a desire to sleep, and we all had severe headaches. The only lively creature was a dear colley [*sic*] puppy. He did not seem to be affected by the air, and romped about in great delight at seeing new faces. The clerks told us *they suffered terribly from headaches*, and were changed every three months, as their health could not stand the climate for a longer time. One of them died not long before. It must be a dreadful life.

Having rested for about half an hour, and written our names in the book, we prepared to descend. My gunny-bags were quite worn through, so I had no protection for my feet. Before starting they took us to an everlasting snow summit. When we looked down—standing on 100 ft. of frozen snow—into an endless crater; it made me shudder. One slip, and all would have been over! The remembrance of it comes back to me as a something never to be forgotten.

Of course, it was easier going down, but very tiring, and we tumbled into deep snowdrifts and struggled out as best we could. I was all the time nearly blind with a terrible headache. Glad, indeed, we were to reach the top of the last steep descent, and to see the timber line below us. I took hold of the telegraph wire—the posts stood about a yard and a half above the snow—and, holding by it, fairly flew down, tumbling into a deep drift as I

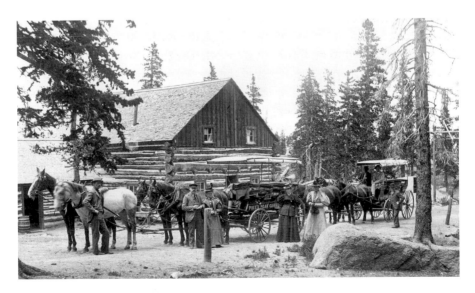

Tourists pose at the halfway house on the carriage line, circa 1887–1900. *Denver Public Library, Western History Collection.*

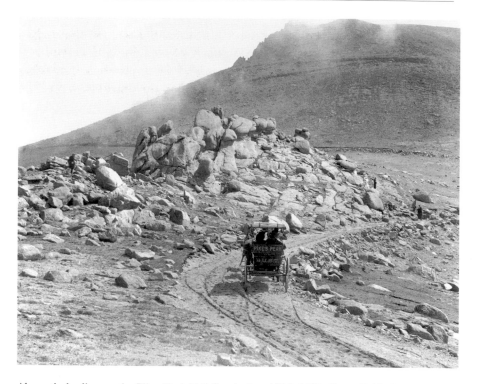

Above timberline on the Pikes Peak Toll Road, circa 1890–1900. *Denver Public Library, Western History Collection.*

released my hold. The men sat down and slid to the bottom. I was helped on to my good little black mule, which with the horses had been left tied up to the trees, and we began our descent. I really cannot remember how we got on. I let the mule take her own way, and sat feeling bewildered and dazed till we got quite out of the pine trees on to the flat. The air by this time was no longer rarefied, and I gradually recovered. It was as if a heavy weight had been lifted from my head. Mr. B--- would not ride down. He tramped on and actually got in before us.

Great was the excitement at the little hotel to know we had got on, and great was the surprise expressed when, after a good hot bath and fresh apparel, I took my place at the *table d'hote* as fresh as if I had done nothing out of the way. Poor Mr. B--- suffered terribly from sun-scorching. His face and neck were severely blistered, and he was burnt a real scarlet; glycerine and rose water gave him a little relief, but it was many days before he recovered from the effects of the sun and snow combined. The poor guide was snow-blind for some days, and the two

Americans went about wearing dark glasses and declared themselves quite knocked up. Thanks to the precaution of wearing a thick veil and neckerchief, I did not suffer in the least; indeed, I enjoyed the whole thing thoroughly, and like to shut my eyes now to recall the grand view and the marvellous colouring.

JUVENILE CLIMBERS

Weekly Republic and Mountaineer
July 1, 1883

Sunday morning at 9 o'clock, a juvenile quartette composed of Bert and Charlie Robbins, sons of ex-Mayor D.W. Robbins, Walter Marlow and Irving Platt, boarded the train for Manitou, fully equipped with blankets and looked as though they were starting out on a prospecting tour in the mountains. After arriving at Manitou all traces of them were lost for the time-being. At noon Monday they again made their appearance in this city and from Bert Robbins we gained the following information regarding their trip. Bert, aged 12 years, says the boys made up their minds to visit Pike's Peak on their own hook and started out for that purpose. When the half-way house was reached Walter Marlow, who is a cripple and compelled to use a crutch, and Charlie Robbins gave up the trip and remained there awaiting the return of Bert and Irving. The plucky little tourists, each carrying their heavy blankets, continued their journey without knowledge of the road or a guide to accompany them until they reached the summit, which they gained at sunset. There they wrapped themselves in their blankets and went to sleep 14,000 feet above the sea as serenely as if at home in their comfortable beds. At 4 o'clock this morning they started on their way down, joined by their companions at the half-way house and reached this city, walking the entire distance, in time for dinner, with an immense appetite, and this afternoon are running around the street just as though they hadn't walked about 30 good miles. Taking into consideration that none of the boys are over 15 years of age their performance is a very remarkable one—never equalled by such youthful pedestrians.

COLORADO SPRINGS GAZETTE

July 22, 1883

Messrs. E.M. Herr, W.T. Wilson and F.S. Woodbury, of Denver, started from the Cliff house last evening to walk to Pike's Peak.

COLORADO SPRINGS GAZETTE

July 24, 1883

—Mr. J.M. Waugh, of Mansfield, O., a member of the Bee line excursion, who is on his way to California, was one of a party that started for Pike's Peak yesterday morning. When about four miles out of Manitou, the girth of his saddle was broken and he was thrown to the ground. His shoulder was dislocated and he was otherwise bruised.

A carriage pauses at the "W" on the toll road, circa 1882–1900. *William H. Jackson photo, Denver Public Library, Western History Collection.*

A carriage pauses for a view at the brink of the Bottomless Pit, Pikes Peak, circa 1882–1900. *William H. Jackson Photo. Denver Public Library, Western History Collection.*

His injuries were attended to and he is expected to be able to continue his journey at once.

—Seven of the party whose names were published in Sunday morning's *Gazette* succeeded in accomplishing the ascent by moonlight starting at 11 o'clock Saturday night and reaching the summit at 8 o'clock Sunday morning. J.F. Daley one of the party gave out near the iron spring and Archie McLeod had to stop at the Lake House on account of sickness. Storer and Coulson led the van both going and coming, and say they would not object to taking the same tramp next week.

Colorado Springs Gazette

July 28, 1883

Mr. Cree, who ought to know, thinks more people went to the peak yesterday than on any day since the total eclipse of the sun five years ago.

LIFE ON PIKE'S PEAK: SOME OF THE PLEASURES OF A SIGNAL SERVICE OBSERVER

Weekly Republic & Mountaineer
August 2, 1883

The life of an officer or attache at the government signal station, is not a bed of roses, full of happiness. Among the many afflictions, none approaches the questions of a tourist for trying the patience. Take a seat and listen to questions propounded by the next sight-seer.

Tourist enters, and gazing around the room, his eyes soon fall on the observer. Walking up to him he begins:

Tourist.—Do you stay here all winter?
Observer.—Yes, sir.
T.—Do you keep warm?
O.—Well, we manage to keep from freezing.
T.—Does the wind blow very heavy up here?
O.—Yes, sir; this is one of the most windy points known.
T.—What is your greatest velocity?
O.—One hundred and forty miles an hour.
T.—Does your building shake when it blows?
O.—Yes, sir; it has a trembling motion when the wind gets up to the rate of one hundred miles an hour.
T.—Do you ever get afraid and think you'll be blown away?
O.—No; but we feel sometimes as though the next blast would take the building.
T.—How cold does it ever get here in the winter?
O.—The lowest temperature here last winter was 40 degrees below zero.
T.—Do you ever get lonely here?
O.—Oh, no; well, hardly ever.
T.—How many of you live here?
O.—Three.
T.—Do you ever go down the mountain?
O.—Yes, sir; we make on an average two trips a month to Colorado Springs, where we remain two weeks.
T.—Are you a married man?
O.—No; nor do I expect to be very soon.
T.—Could you keep a wife here in the winter?
O.—No; I don't think I could.
T.—Have you any garden up here?

O.—Oh, yes; we have onions, potatoes, corn and all vegetables.

T.—Where is your garden?

O.—Up stairs—in cans.

T.—What do you call that thing? (pointing to an instrument).

O.—That is an anemometer; it indicates the number of miles the wind travels per hour.

T.—What is that?

O.—That is a self-registering attachment to the anemometer; it records on paper the number of miles traveled by the wind.

T.—What are those?

O.—Those are barometers; they measure the weight or pressure of the atmosphere.

T.—And that?

O.—That is our pluviameter or rain gauge; it collects the amount of rain or snow fall.

T.—(Going to the window). What is in this window?

O.—Those are the thermometers; namely, the exposed and wet bulb thermometers, which combined are an [sic] hygrometer; the other two are minimum and maximum thermometers, which give the highest and lowest temperatures in twenty-four hours.

T.—(Then goes out after saying) If you ever get down to Pueblo be sure to call on me. Won't you smoke? Have a cigar? (He then goes out, but observing the anemometer and anemoscope on the roof, he rushes to have a full explanation in regard to them.)

T.—And this is where you live?

O.—Yes, sir.

T.—How many stoves have you?

O.—In winter we have two, in summer only one.

T.—How much wood do you burn?

O.—We count on thirty cords to last a year.

T.—Is this a government observatory?

O.—Yes, sir; we are the United States signal service observers.

These questions, and perhaps many more equally as silly, are asked by almost every tourist who ascends the peak, and it is little wonder that the observers get just a trifle tired.

Rocky Mountain Sun

December 22, 1883

Anna Dickenson is the only person who ever succeeded in driving a mule to the summit of Pike's Peak. The poor mule met his match at last.

Rocky Mountain Sun

November 28, 1885

The rarefied air made the poor ponies pant as they put out their hoofs among the rocks near the summit; and let me advise those of our sex who ascend Pike's Peak to loosen their corsets before starting.

—Woman quoted in the *New Orleans Picayune*

Manitou Springs Journal

July 17, 1888

The many attractions surrounding the Half-Way House make it a most desirable place to spend a week or month. Beautiful walks, horseback rides and good trout fishing. Only four miles from Manitou. Rates, $3 per day, $12 per week.

Lightning Does Frightful Work on Pike's Peak

Colorado Springs Gazette
August 21, 1888

The visitors to Pike's Peak from Manitou yesterday brought back the story of a frightful and probably fatal happening on the summit. A severe electric

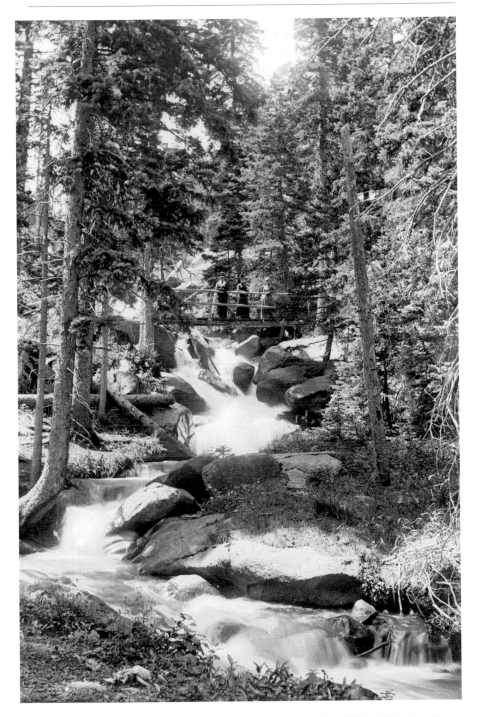

Tourists enjoy the cascades at the halfway house, circa 1882–1900. *William H. Jackson photo, History Colorado.*

"The Approaching Storm. Pikes Peak Carriage Road," circa 1882–1900. *William H. Jackson photo, History Colorado.*

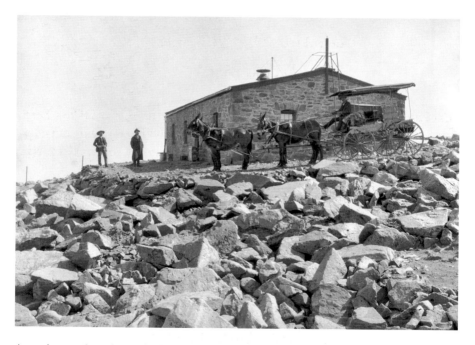

A carriage and tourists at the Signal Station, 1880s. *William H. Jackson photo, Denver Public Library, Western History Department.*

storm, accompanied by a heavy fall of hail, occurred between two and three o'clock in the afternoon, and the visitors took refuge in the signal station. Miss Laura Cook, aged fourteen years, daughter of Mr. George D. Cook, of Chicago, was standing in the open doorway while the storm was at it its height, gazing at the raging elements. Suddenly, and simultaneously with

a deafening crash, a blinding light filled the room and the spectators were horrified to see the blue blaze of a lightning bolt strike the unfortunate girl full in the face and circle downward around her body. She was knocked senseless to the floor, and a fearful sight met the eyes of her relatives and friends who crowded around her. Her head was swollen to an enormous size and her body and limbs were cut in stripes and horribly mutilated. Very little could be done to relieve her sufferings, which were intense, but a messenger was immediately dispatched to Manitou for a physician. The Manitou party left the summit about three quarters of an hour after the accident. At that time the wounded girl was uttering heart-rending screams, and it seemed the general opinion that she could not live.

COLORADO SPRINGS GAZETTE

August 28, 1888

Miss Laura W. Cook is rapidly recovering from her injuries on Pike's Peak. Some one suggested that she accept an engagement with some dime museum as an instance of having been struck by lightning almost above the clouds, and the wonderful cure effected by the Colorado climate.

UP ABOVE THE CLOUDS!

DRAWN BY FOUR-IN-HAND

THE CARRIAGE ROAD TO PIKE'S PEAK IS NOW COMPLETED

Colorado Springs Gazette – Advertisement
September 9, 1888

We can drive you to the summit of the Grand Old Mountain behind four nice horses. Our drivers are the best; our carriages most comfortable; our horses are good; our road is pronounced by all to be the Safest and Finest Mountain Road in the World. We have a relay of horses at the Half-Way

House. By changing horses half way enables us to make much better time and is more pleasant for our patrons.

Take the 7.40 Midland Train to Cascade.

Then you will find four-horse carriages or saddle horses to convey you to the Summit of the Mountain, bringing you back in time to catch the six o'clock train home.

Fare $5.00 From Cascade.

For seats inquire at J.E. Hundley Stable, Colorado Springs, or Will G. Campbell, Cascade.

PIKES PEAK RAILWAY: A NEW ROAD TO BE BUILT OVER THE OLD MOUNTAIN TRAIL

Denver Republican
October 7, 1889

The *Colorado Springs Republic* says: "For several days past Mr. Langtry, contractor for the grading of the Pike's Peak & Manitou Railway, has been packing supplies and grading utensils up the Ruxton trail to the camp on the summit of the old mountain. Active work was begun on Friday. A force of 200 men are already at work. The start is made near the summit, and Mr. Langtry hopes to have the work above timber-line complete before cold

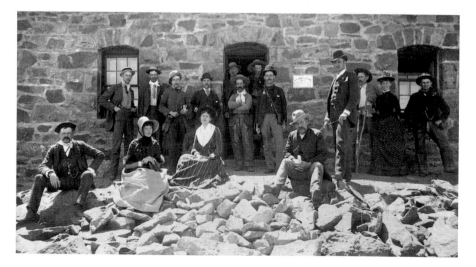

Tourists pose at the Signal Station, circa 1890. *History Colorado.*

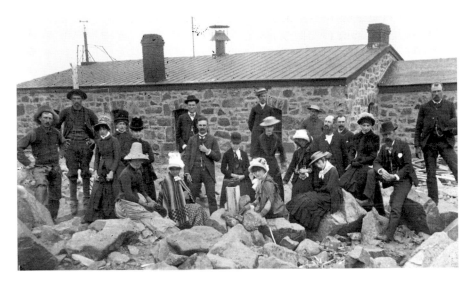

Pikes Peak summit party, circa 1880s. *Pikes Peak Library District.*

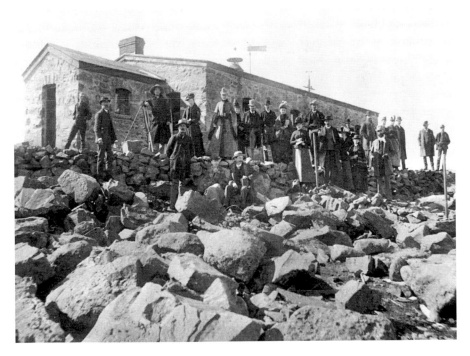

Press excursion, September 6, 1888. *Pikes Peak Library District.*

weather sets in. The present terminus of survey for the road is near the iron spring, and the question is now being agitated among the directors whether it would not be wise to bring the line down farther into town, and a survey down the north side of Ruxton glen has been made for that purpose. The terminus of the road would then be at the spot where Gillis Brothers lumber-yard now stands, which would be an admirable location for the depot."

Rocky Mountain Sun

October 19, 1889

Views from Pike's Peak—

The signal service officer at Pike's Peak said to a correspondent the other day: "Sometimes I stand at the window with my telescope. I can see the houses of Colorado Springs, twenty miles away, the men sitting in their shirt sleeves sipping iced drinks to keep cool, the ladies walking about in white summer robes. I lower the glass. The summer scene is gone. Green trees, animal life, men and women fade away like creatures in a dream, and I am the only living thing in a world of eternal snow and ice and silence."

—A carriage road to the top of Pike's peak has just been completed. It begins at Cascade canyon, and extends sixteen miles until it reaches the very summit, 14,147 feet above sea level. At one point on the road one can see locomotive smoke ninety miles away.

Littleton Independent

June 13, 1890

It was eight degrees below zero on the top of Pike's Peak a few mornings [ago].

ROCKY MOUNTAIN SUN

May 2, 1891

The management of the Pike's Peak Railway has invited President Harrison and party to ascend the mountain on the new road.

MANITOU SPRINGS JOURNAL

May 28, 1891

Of the features of the Ruxton trail is the Half-Way House, or Trail House, built nine years ago [1882] by Thomas T. Palsgrove. The house is constructed of huge logs, well plastered, containing besides kitchen, dining room, and parlor, sufficient bedrooms to accommodate fifty persons. Two

Loaded with dynamite, tools and a sign, "I Helped Build Pikes Peak Railway," two burros guard the tracks of the newly built cog railroad, circa 1890. *William H. Jackson photo, Denver Public Library, Western History Collection.*

large fireplaces, with big andirons, heat the lower two rooms. Near by is a building containing a bowling alley, shooting gallery, billiard and pool tables for the guests. It is quite the thing to leave Manitou in the afternoon, take supper and spend the night at the Trail House, starting for the summit in time to see the sunrise. The house is surrounded by many points of interest such as Grand View Rock, Cameron's Cone, Hell Gate, etc. Parties walking from Manitou to the Trail House will find horses, burros and guides at their command. Mr. Palsgrove will meet picnic parties at the Iron Springs and convey them to any point. Last year 3,800 people registered. The Halfway House is on the line of the Pike's Peak railroad and a depot is located near the hotel, at which all trains will stop.

D.H. Rupp returned yesterday from the summit, where he has been staying and ministering to the want of hungry wayfarers since Sunday. He claims that he can make a light biscuit, but one of his guests declares that one that he ate was so heavy that it made his horse tired coming down. (Weir & Rupp were at that time making the old signal station into a hotel for tourists.)

MANITOU SPRINGS JOURNAL
May 29, 1891

The hotel on the summit will be opened June 5, when it is expected the carriage road will be opened, and will continue open as long as there is any travel to the summit. The hotel will have accommodations with beds and cots for fifteen people. There will be a first class lunch counter at which short orders [sic] breakfast and suppers will be served for those staying over night. The food served will be all fresh goods, not canned, and [a] competent chef will do the cooking. The drinking water will be brought up by the trains from the cool and perfectly pure spring below "Windy Point." At the summit also will be a stand for the sale of Pike's Peak curios exclusively. A very handsome souvenir spoon has been designed and will be manufactured especially for this trade. In addition there will be kept specimens of Amazon stone, blue quartz, green granite, semi-precious and precious topaz, agate and a kindred line of goods, all from the peak. By a special arrangement with J.G. Hiestand there will be a photo studio at the summit for taking views of parties or tourists.

MANITOU SPRINGS JOURNAL

June 10, 1891

D.H. Rupp has returned from the summit…he brought several of his biscuits down and distributed them among friends, who will have them cut and polished as souvenirs.

MANITOU SPRINGS JOURNAL

June 17, 1891

Among the few who have made the ascent of Pike's Peak on foot this season are Mrs. Edward Bottomly, Mrs. Edward Graham, Mrs. Rubie Best and Mr. L. Bryant. They made the climb on Sunday, starting at 5 a.m. and returning at 8 p.m. They found a great deal of snow, but it was crusted over so that they could walk safely upon its surface.

A group of tourists take advantage of the wide, level path created by the new cog road, circa 1890. *L.C. McClure photo, Denver Public Library, Western History Collection.*

Manitou Springs Journal

June 18, 1891

Weir & Rupp have had a very beautiful souvenir prepared for sale upon their Pike's Peak railway stands. It is entitled "Glimpses of Pike's Peak and Surroundings," and contains twelve pages or 98 views of the line of the cog road, the summit, Ute Pass, Garden of the Gods and others of the beautiful surroundings. The views are "albertype" reproductions of photographs and are very soft and delicate in tone. It will be a beautiful souvenir of a trip over the road, and is the most beautiful collection of Manitou views prepared for sale.

Manitou Springs Journal

July 2, 1891

J.G. Hiestand has developed the pictures of the first train to the summit taken the other day and finds them all thoroughly successful. The features of the members of the party are all plainly distinguishable. Mr. Hiestand secured the only negative of the first train on the summit, and although it was almost six o'clock and the sun was behind a cloud, the picture was a success.

Finished – The First Passenger Coach Stands Upon the Summit

Manitou's Greatest Engineering Feat Is Formally Opened

Manitou Springs Journal
July 4, 1891

The first passenger train to reach the higher terminus of the Manitou and Pike's Peak railroad made the ascent Tuesday afternoon.

...The history of its inception and construction are familiar to almost every reader of this paper. The scars upon the mountain sides above

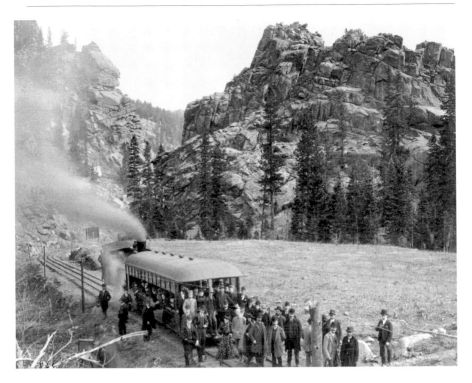

The first train of the Manitou and Pikes Peak Railway pauses at Ruxton Park, June 29, 1891. *Ogden S. Irish photo, Denver Public Library, Western History Collection.*

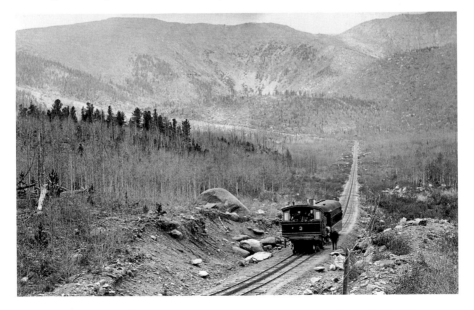

The railway line at Ruxton Park, circa 1891–1910. *H.S. Poley photo, Denver Public Library, Western History Collection.*

Manitou show where an attempt was made some years ago to build a road to the summit on the regular system with smooth rails, but capital was wary of this somewhat quixotic scheme, and it died after a few miles of grading had been done. In 1889 the Manitou & Pike's Peak Railway company was organized, with Major John Hulbert, its chief promoter, as president. Work was at once commenced building the grade up through Engleman's glen, Lion's gulch and up the granite slopes of the peak itself. Heavy storms came at the high altitudes, and it was hard to get or to keep men at work, but still the company relaxed none of its efforts to get the work done. It was hoped to complete the road by July 1, 1890, but the months rolled by, material failed to arrive, and delays arose in the grading, so it was not until the 20th day of October, 1890, that amid deep and drifting snows and cold winds of the approaching winter that the last rail was laid and an engine stood alongside the old stone signal house.

But the work was still far from finished. The laying of the rails had been done hurriedly so that the friction from the uneven cogs was enormous; culverts and ditches had to be built, the engines had to be overhauled and changed in some respects. The snows of winter soon put a stop to this work, but early in the spring men were again at work, gauging the cog rails, putting down planking to bind the whole track firmly together and surfacing. This work has taken a small army of men, but at last it has been finished and the trains are running.

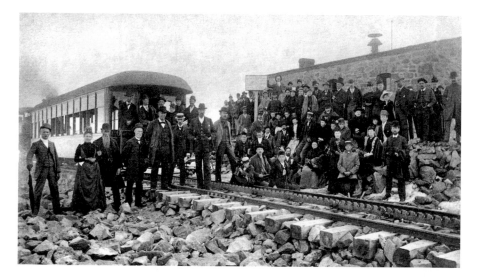

A distinguished group: the first excursion train to the summit, June 29, 1891. *J.G. Hiestand photo, History Colorado.*

The first summit train left the depot at about 1:20 Tuesday afternoon [June 30], bearing a Denver excursion. A train leaving at 8:23 in the morning which it was intended should go to the summit, bore a large party of invited guests of the road. There were fifty in all in the party; [including] Mayor Leddy and Z.G. Simmons [of mattress fame, who financed the project]. The ride up was a lively one and at each stop for water the party were photographed by Messrs. Hiestand, Mellen, Imes and Boynton. At the Half-Way house, Mr. Palsgrove gave the party a hearty greeting but no stop was made. At the switch in Ruxton park where the supplies for Lake Moraine are laid off the genial face of David McShane was discovered and he was at once made one of the party. Just above timber line it was found that the rocks that slid down on the track Sunday night were still blocking the way. A portion of the party went on up to the top to await the coming of the train in the afternoon. After picking some specimens of alpine vegetation the rest returned to the cars and returned to Manitou.

MANITOU SPRINGS JOURNAL

July 6, 1891

Judging from present appearances, Photographer J.G. Hiestand will have 1000 negatives of summit parties before the season is over.

BUENA VISTA HERALD

July 19, 1891

There has scarcely been a day since the opening of the cog line to the summit of Pike's Peak but that there has been at least 100 persons made the ascent.

BUENA VISTA HERALD

October 17, 1891

The summit of Pike's Peak was the scene of an event last Thursday which perhaps never occurred at so high an altitude.

A.B. Froman and Miss Emma J. Michael of Colorado Springs were there joined in marriage, the Rev. J.P. Lucas, also of Colorado Springs, performing the ceremony, which took place in the open air on the highest point of the mountain. About sixty people, comprising the train load on the cog-wheel road, were witnesses of the event.

PART IV

1892-1901

ROCKY MOUNTAIN SUN

July 23, 1892

A novel and interesting feature among Colorado's attractions at the World's Fair is promised from Cheyenne Canon in the form of a burro with a real

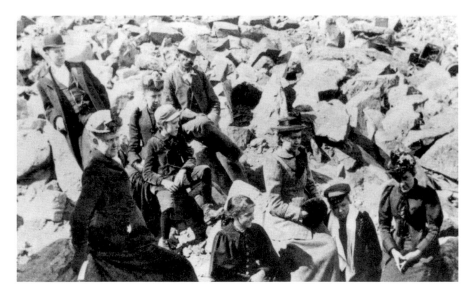

"On Pikes Peak," August 31, 1892. *Pikes Peak Library District.*

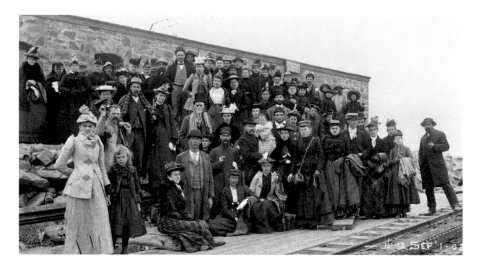

Pikes Peak summit, September 1, 1892. *J.G. Hiestand photo, Denver Public Library, Western History Collection.*

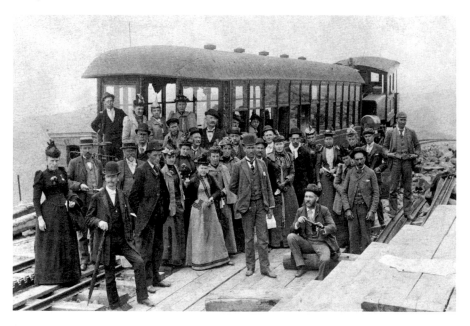

Pikes Peak summit, June 29, 1892. *J.G. Hiestand photo, Pikes Peak Library District.*

record. This animal's claim for distinction is based on the fact that it carried the first load of lumber used in the construction of the United States signal station to the summit of Pike's Peak. He is known as Colorow and is as fat as the chief was.

FIELD & FARM MAGAZINE

October 22, 1892

The First Woman of Pike's Peak: It is pretty safe to wager that nine-tenths of the tourists that visited Colorado from the east and California this summer ascended Pike's Peak. Now the feat is easily accomplished; all one has to do is take a seat in the cog train and in a short time the summit of Pike's Peak is reached. But twenty-five years ago there was no way of getting there except by footing it, and to Mrs. J.W. Powell, wife of Major Powell one of the government's old time geological surveyors, is due the honor of being the first of her sex to ascend this sublimity.

WANDERING ON TOP OF THE PEAK: NARROW ESCAPE FROM DEATH

MANITOU MAN'S TERRIBLE EXPERIENCE ON PIKE'S PEAK

Buena Vista Herald
October 29, 1892

A.J. Sawyer, of Manitou, had a narrow escape from death last night and Saturday. He had been engaged by the signal service on Pike's Peak to store away some coal and [wood] for the winter. He left Manitou early Friday afternoon for the ascent, and at 6:30 in the evening reached the saddle house in safety. The building has a telephone and, *communicating with Observer* Myers on the Peak, he told him that he had reached there, and being rather tired might not go any further that night. But in about ten minutes he called up again and said he thought he would complete the journey at once.

All night long he was expected, but when Saturday morning arrived and he failed to appear there was increased anxiety. Observer Myers and the cook at the station decided to start out through the snow and find him, and acting on this spent nearly the entire day searching for the missing man. He was found just at night with both hands and both feet frozen and nearly dead from cold and exposure.

He had lost his way in the darkness and slipped over a precipice 700 feet high. His fall was broken by snow or he would have been dead when found. As it is he is in a precarious condition. To the bravery of Mr. Myers, the observer, and his cook the man owes his life.

PIKE'S PEAK VICTIMS

THREE MEN BADLY HURT BY TRYING TO SLIDE DOWN THE COG-ROAD TRACK

Buena Vista Herald
August 13, 1893

Three venturesome men had a marvelous escape from instant and terrible death on Pike's Peak Sunday, and as it was they were all badly injured.

The party, which consisted of Richard Wood, a hack driver whose name is said to be King, and another man, all of Manitou, were descending from the summit on a contrivance called a "toboggan" by the railroad men. This consists of a flat board nailed over a groove which sits closely on the track rail of the cog road. Light arms reach over to each rail side to steady the machine and form a foot-rest. A lever pinching down on the center serves as a brake.

The men left the summit at just seven o'clock, sitting tandem on the board. The speed of the toboggan has always been terrific, the distance of over nine miles, including the necessary three stops, having several times been covered in less than 16 minutes. This time it was proposed to beat even this wild record.

They started off all right, gaining speed with every yard from the start. One stop at the upper tank was successfully made. Then came the steep pitch above Windy Point, and then the Point itself. Here they passed some parties who were walking down and whom it had taken two hours to come from the summit, although the toboggan had made the distance in less than five minutes.

Not a word of fear was given as the sliding board shot past, although it struck the pedestrians that something was wrong. From each arm, where it struck the rail, there extended a trail of fire at least two feet long, and from under the seat there was another, endangering the flying coat-tails of the man sitting behind.

"Above Timberline," Pikes Peak Cog Road, circa 1891–1910. *H.S. Poley photo, Denver Public Library, Western History Collection.*

Below Windy Point there is a sharp turn, at the top of "Son-of-a-Gun Hill," the steepest point in the whole road. Here the brake must have become useless, for the toboggan and its human cargo shot madly down the decline beyond all control. At the first slight turn the frail board jumped from the rails, leaping into the air for a fearful distance and throwing the three men away out over the mountain side.

None of the men struck earth within thirty feet of the track, and one of them, Wood, landed a full seventy-five feet away. The surface here is entirely of rough broken rock, with jagged edges. The men struck on this, being terribly cut and bruised. Two of them were able to pick themselves up shortly but Wood was unable to stir. Help was procured and he was carried to Manitou where he was cared for.

Wood's leg was broken below the knee and hardly an inch of flesh remained unbruised anywhere on his body. The other two men were cut up terribly, great gashes being cut in their heads, arms and bodies. One of the men had an ear entirely torn off. All three may die, although it is now thought that they will recover.

ROCKY MOUNTAIN SUN

June 9, 1894

During the storm last week seven feet of snow fell on the summit of Pike's Peak.

A big ball of snow blocks passage on the cog railway, April 21, 1901. *History Colorado.*

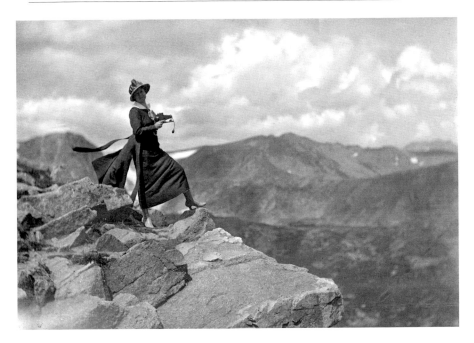

A fashionable tourist poses atop a precipice near the summit, circa 1900. *H.S. Poley Photo.*

LITTLETON INDEPENDENT

September 14, 1894

A remarkable feat of heliographic signaling was performed recently when the sunbeams carried a message from the Equitable building to the top of Pike's peak, an air-line distance of sixty-six miles. The flashes of the mirrors on Pike's peak could be seen by the naked eye during the transmission of the message. The peak was first "called" from the Denver end of the line and within five minutes after the operations began [a] responsive flash told that Pike's peak was ready to talk.

—*Rocky Mountain Herald*

PIKES PEAK BY MOONLIGHT,
BY W.C. CAMPBELL

Collier's Magazine
November 1894

Above timber line, above vegetation of any kind, above the clouds, the daring enterprise and skill of the civil engineer and the business sagacity of the restless American capitalist have pushed the iron horse onward and upward to the very summit of that grand old monarch of the Rocky Mountains, Pike's Peak.

There are a number of higher mountains in the United States. Indeed, there are twenty-three slightly higher ones named in Colorado alone. There are more typical mountain peaks—peaks that stand out in bolder relief. Such are Mount Rainier, in Washington, Mount Hood, in Oregon and Mount Shasta, in California, which, seen as they are from near the sea level, are indisputably more conspicuous. Still, Pike's Peak is wonderfully grand and awe-inspiring. Then, too, its historic associations are such as to excite one's curiosity.

It was first sighted by Lieutenant Zebulon Montgomery Pike, after whom it was named, in the fall of 1806. He wrote: "No human being could ascend to that summit." How little did he dream that within that same century human beings would make that ascent without effort!

The gold excitement of 1859 put the name "Pike's Peak" on everyone's lips. The Supreme Court of Kansas recently decided that Pike's Peak was in those days within the limits of the Territory of Kansas. Then the "Pike's Peak region" was the Mecca of fond hopes, the alluring acme of avaricious ambition, and the fatal snare of disappointment and despair. "Pike's Peak or bust," inscribed on many an outgoing white-canvassed "prairie schooner," and the familiar "Busted, by thunder!" on the returning journey, told the tale most epigrammatically. Tourists at Manitou now smile when they see a four-horse team driving up in front of the hotel, disclosing on the rear of the carriage, in flaming red and gilt letters, the old-time motto. It is humorous now; it was pathetic a third of a century ago. Later, in the early '70's, the smoke of the approaching locomotive on the distant plains to the eastward might be seen. From the top of the old peak they must have seemed, even with the aid of the most powerful lens, in an air itself wonderfully transparent, like Lilliputian skippers in a Brobdingnaggian expanse of blue.

Soon thousands of people were daily gazing from windows at the fair and shining summit. Wherever they might go, from Denver to Pueblo, they raised their eyes to see the mute sentinel to the mid-continent fastnesses, and were not disappointed. It seemed to follow them. Then adventurous tourists began to tell

their Eastern friends of scaling on foot its heights, and of the glorious sunrise view that rewarded their intrepid daring. Later, in 1889, a carriage road was built from Cascade, and then the journey to its top and return were made from Manitou between breakfast and supper. Another year, and the round trip could be accomplished by rail in a little over four hours.

To describe this wonderful railroad and the scenery, which at every turn of its nine miles is kaleidoscopically revealed to the eye of the tourist as he sits in the luxurious car and gazes in wrapt [*sic*] amazement out of the broad windows, one wishes to rely more upon the aid of a camera than upon his descriptive powers, however Talmagean his vocabulary or imagination. The railroad was completed October 20th, 1890, but not regularly opened for travel until June, 1891. It is without counterpart on the Western Hemisphere. In point of elevation overcome and maximum elevation attained it is the most remarkable in the world. It is similar, however, in essential respects to the cogwheel road at Mount Washington.

It is standard gauge, with wide and substantial roadbed and heavy steel rails, the traction devolving upon two heavy serrated rails in the centre, upon which operate six cogwheels underneath the locomotive. It is built on the abt system (in use in Switzerland) [named after inventor Roman Abt, who developed a double-rack system first used in 1885], and the peculiar mechanical construction of both track and locomotive it is claimed renders it absolutely safe. The length of the track is 46,992 feet, in which there is a total ascent of 7,525 feet, or an average of 844.8 feet to the mile, making an average grade of sixteen percent. The steepest grades are a rise of one foot in four. The bridges, of which there are only four, are entirely of iron and masonry. The track in the steepest places is firmly anchored every two hundred feet. There are no trestles. The locomotives are without tenders, unique in appearance, and weigh twenty-eight tons each when loaded. They push the cars on the ascent and precede them on the descent. The coaches are largely of glass, to facilitate observation with seats so arranged that most of the time passengers have a level sitting.

The road is only open for about three or four months in the year, hence those engaged in the operating department have nice, long vacations. During the busy season several trains are run daily, with additional excursions when the moon is full. Taking the train at five o'clock p.m. at the picturesque little depot just above the Iron Springs, at an elevation of 6,622 feet—an elevation greater than the top of Mount Washington—the locomotive whistled (it has no bell), and we were off for our skyland destination. It is upgrade from the very start to the finish, and the engine puffs laboriously, as if rarefied air affected its breathing.

We are at once in Engleman's Canon, which is followed for nearly three miles along the dashing and foaming waters of Ruxton Creek, at times near level, again hundreds of feet above. About one mile from the depot we pass two great rocky points, crested each with a huge bowlder [*sic*], known as Gog and Magog, which we have been looking up at, but are soon to look down upon. It is not infrequent now to see towering above our path in a threatening way a bowlder covering an area nearly as large as an ordinary city lot. The "Grand Pass" for 2,000 feet is one of the longest and steepest; then we pass "Hanging Rock" on the right, and then, in quick succession, "Artist's Glen" and "Sheltered Falls" and arrive at "Minnehaha Falls," where the enterprising "town boomer" has staked off a site. The train has made a few stops, and the passengers have gathered armfuls of beautiful wild roses, verbenas, columbines, marigolds, bluebells, larkspurs, asters, sunflowers, pink gilias, purple penstemons, the cream-colored soap weed, and many kinds of flowers not now called to mind.

Flowers grow in profusion at still greater heights. One wonders how they ever found their way there, and how such delicate things, as we are accustomed to regard them, can withstand such cold. They form their splendid procession on the plains in early spring, moving to the foothills, and then up the mountain sides as the season advances and the snow melts; the same varieties blooming weeks later in the mountains than on the plains. Thus the character of vegetation is constantly changing with every few hundreds of feet elevation.

We now pass the "Devil's Slide" with its lofty "Pinnacle Rocks," and see far above, to the right, a rustic pavilion with a shred of the Stars and Stripes floating from its staff. In what bold relief it stands out in the clear blue sky! The views of the peak, and Manitou, and surrounding country, from this "Grand View Rock," are indeed grand. It is reached by trail from the "Halfway House," a cozy little retreat among the pines. Thus far we have had the music of the rollicking Ruxton Creek all the way; while chipmunks have scurried from rock to rock, crying out at times as if resenting our intrusion.

Again we start on the upward journey, and passing through a narrow defile, known as "Hell Gate," are in Ruxton Park, a comparatively level valley covered with green grass, pine and aspen groves. The round smooth head of "Bald Mountain" is now seen in the distance. In passing "Lion's Gulch" we get our first grand view of Pike's Peak. How far we have already climbed and yet there it is, still towering above us!

Now we part company with the trees, which have been growing smaller and gnarled and twisted, for we are now 11,625 feet up—"timber line." A sharp turn and the train has passed "Windy Point" and is climbing into the "Saddle." Whoever christened these various places had an eye for the proprieties, as well

as a seeming regard for "hell" and the "devil." Then for a mile and a half there is nothing but broken rocks and drifted snow in patches.

At last we are at the abandoned old government signal station, now used as a hotel, 14,147 feet above the sea—Pike's Peak. A blazing fire in a large stove is found, though it is midsummer. Some shiver about the stove, others in winter wraps walk over the seventy-acre mass of broken, irregular-shaped and sharp-cornered rocks, and gaze and gaze. Some of our party bled at the nose, and a few experienced difficulty in breathing, caused by the rarity of the atmosphere.

All our party, save the "colonel" from Texas had a feeling of personal inconsequence, and were wrapt in silent contemplation of the sublimity and awfulness of nature's grandeur. How petty poor frail humanity seemed! He is indeed conceited who does not feel his own individual insignificance as he looks down over the outspread world, beholding a city at his feet, looking like a mere checkerboard—the plaything of a child. Beyond are the billowy plains,

"Bathed in the tenderest purple of distance
Tinted and shadowed by pencils of air"

while below and all around are mountain ranges and peaks, some snow-capped and pretentious, yet all kneeling and acknowledging the supremacy of their grand old monarch. Someone has well said that "here the eye conveys to the soul a suggestion of the infinite."

The poet was about to attempt a suitable apostrophe when the spell was broken by the "colonel" volunteering the observation that for "scenic grand'ur I think I hev nevah saw, sah nothin' thet would thrill any moah as does this; an' I may say I hev been from Texas to Californy an' back agin, twice."

There were in the party some gentlemen and ladies who had also traveled; these agreed with the "colonel" and smiled good-naturedly. Again the "colonel," with commendable fealty to the great State of his nativity, took occasion to remark that "Texas is a continent in itself," as if the thought were inspired by his surroundings and would not keep for lower levels or more commonplace occasions.

The sun was now sinking below the western horizon, and the soft and golden coloring of the long twilight cast weird shadows over the deep places below. As daylight faded gradually away the full round moon came creeping up the eastern sky, as if making an ineffectual effort to keep in sight of the swifter orb of the day. The lingering, deflected rays of the sun blended with the mellow softness of the moonlight, tinting with a wonderful haziness the mountain tops, while the blue shadows in the canons and valleys below grew

darker and yet darker until they assumed a settled and melancholy gloom. The scene was incomparable, enchanting, indescribable in mere cold words.

Meantime, the superlative "colonel" having subsided, the poet tried his hand with the following result:

SUNSET ON PIKE'S PEAK
The sun is sinking to his rest,
The fleecy clouds fantastic play
Upon the mountain's shining crest
As if most loath to part with day.

The coldest blue with warmest red
Cast o'er the silent skyland scene
Their varied tints that quickly spread
While weirdest shadows fit between.

The mountain tops seem soothed to sleep,
His golden rays so gently go,
Yet he will kiss them—kiss them sweet,
For aye and aye, we surely know.

How like life's close this sunset rare!
We feel the shades of night come on,
And through the gloom of dark despair
Await the golden paragon.

The locomotive's whistle interrupted his reverie.

Then down, down, down and down we go, each yawning canon looking like some mighty monster with open jaws waiting to devour us. But steady hands and cool heads manage the brakes and throttle, and soon we cease to fear.

The distant stars are shining brightly; the fragrant pines lift their shadows further and further; the naked rocks now peer from mantles of green; the great rocky pinnacles that frowned on us as we went up seem to smile on our return; the dark green willows and currant bushes wave to and fro in the soughing wind like flags of welcome in the hands of little children; the melodious dashing of the waterfalls and the "little sharps and trebles" of babbling brooks drift in at the car windows in joyous greeting; the twinkling starlike lights below us come nearer and nearer; at last the engine ceases its violent puffing as if tired out and exhausted, and the conductor quietly calls, "Manitou!"

HIGH AND MIGHTY

Rocky Mountain Sun
April 17, 1897

Newspaper enterprise in Colorado knows no bounds, and no altitude in the state seems too high for the enterprising pencil-pushers to ply their vocations, says the *Colorado Springs Gazette*. The latest aspirants for "newspaporial" fame which will be sought above the clouds at an altitude of 14,147 feet above the sea level, are Messrs. T.B. Wilson and J.E. King, who have made the final arrangements with the cog road whereby they will publish during the tourist season a semi-daily, four-column eight-page illustrated paper on the summit of Pike's Peak. They will also engage in the job printing business. It is safe to say that they will be nearer Heaven than the majority of newspaper men ever get. The paper is expected to have quite a large circulation among the tourists who will visit the peak this summer. It will also be placed on sale at all the leading hotels in

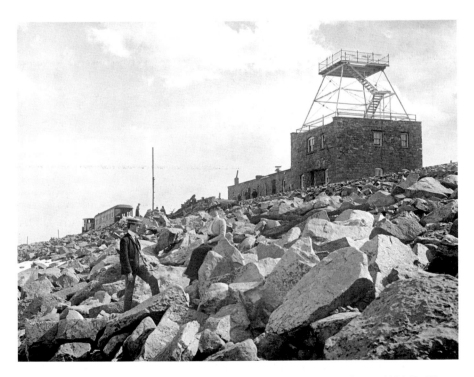

Station and hotel, summit of Pikes Peak. *Photo by Detroit Publishing Co. no. 013813. Library of Congress.*

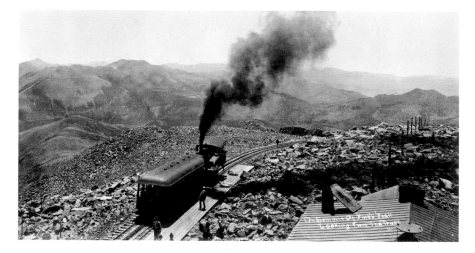

Higher than the summit. The view from the observation platform, built in 1899. *J.G. Hiestand photo, History Colorado.*

the United States. The paper promises to be quite a novelty as it will be published at a higher point than [any] other newspaper in America if not the world. It will be called the *Pike's Peak News.*

TOURIST MURDERED AND ROBBED NEAR THE SUMMIT OF PIKE'S PEAK
Rocky Mountain Sun
August 21, 1897

The body of the man supposed to have been murdered some time late Wednesday or early Thursday morning above timber line near the summit of Pike's peak has been identified as that of H.H. Key of Wisner, Neb.

Key was a tourist and had been in this city and Manitou about a week. When last here [Colorado Springs] he had over $200 in money in his pocket. He started to walk to the summit of the peak on Wednesday night, and late yesterday his body was found wedged into a culvert along side the cog railroad with a bullet in his brain and his pockets rifled.

There is no clue to the murderers.

APPREHENDED IN KANSAS CITY

CIRCUMSTANTIAL EVIDENCE STRONG AGAINST HIM

Colorado Springs Gazette
August 27, 1897

John B. Edmunds, who[m] the finger of suspicion has pointed out as the murderer of Herbert H. Kay, whose dead body was found on Pike's peak Thursday morning, August 19, was arrested in Kansas City yesterday morning by detectives Ennis and Hayde of the Kansas City police force on instructions received from Sheriff Boynton, and he is now being held by the authorities until a requisition is secured and an officer sent for him.

The first information of the arrest of Edmunds came in a telegram to the Sheriff yesterday at noon. It read as follows:

> *W.S. Boynton, Sheriff, Colorado Springs:*
> *I have arrested John Edmunds. Send officer. Will not go back without papers. Answer. John Hayes, chief of police.*

Sheriff Boynton was considerably elated and immediately telegraphed to have a photo taken and forwarded to him at once. When the photo arrives it will be submitted to the young ladies who met Kay and his companion while walking up the cog road on the fatal night, and if the young ladies recognize the murderer by the photograph Sheriff Boynton will immediately take steps to have Edmunds brought back to Colorado Springs for trial. This will necessitate the securing of requisition papers from Governor Adams and an officer visiting Jefferson city to have the governor of Missouri honor the papers before Edmunds can be brought back.

ARREST OF EDMUNDS

Special to the Gazette

John B. Edmunds, who is wanted at Colorado Springs for the murder of Herbert H. Kay, on August 19, was arrested by Detectives Ennis and Hayde. Edmunds was until a few days ago office boy for Dr. Fraker. Chief of

Police Hayes received a letter from W.S. Boynton, sheriff of El Paso county, Colorado, Thursday, giving a description of Edmunds. It was also stated that a reward of $500 would be paid for the arrest of Edmunds.

Detectives Ennis and Hayde were detailed on the case, and at once repaired to the residence of Edmunds' father, 409 Landis court. The detectives found Edmunds under a bed, pulled him out and took him to police headquarters. As soon as Edmunds was ushered into the presence of Chief Hayes he became very angry, and before he had been told what he was wanted for said, "I was in Larned, Kan., on August 19."

Chief Hayes takes this statement as a partial admission of guilt, as Edmunds had not been told that he was wanted for the murder of Kay. When arrested Edmunds had a trunk packed and was preparing to go to Galveston, Texas, and then to sea. He will be turned over to an officer from Colorado.

As it turned out, despite his self-incriminating behavior, Edmunds was not guilty of this crime.

STRONG EVIDENCE – CHARGED WITH TWO MURDERS

SHIRLEY D. CHAMBERLAIN ARRESTED FOR THE KILLING OF KAY AND SCHMIDT AT COLORADO SPRINGS

Colorado Transcript
December 8, 1897

The alleged murderer of Herbert H. Kay of Windsor, Nebraska, who was shot down from behind and instantly killed is now in solitary confinement in the county jail in this city [Colorado Springs]. The same man that murdered Kay in such a cold-blooded manner also murdered the Russian Jew, Schmidt, in his Huerfano street shop early in the month of September. The work of running down this suspect was carried on under the most adverse circumstances, and the capture reflects the greatest possible credit on Chief Gathright and Detective Atkinson of the city police department.

The story of the Kay murder has been told and re-told, and the details of that awful crime are familiar to the reading public. The murder of the

Russian Jew, though equally sensational, attracted less attention because of the lack of prominence of the murdered man.

The story of the two murders reads like a detective novel, and the chain connecting them is complete. The alleged murderer of Kay and Schmidt is Shirley D. Chamberlain, alias George Dean, an ex-convict from Canon City, who was arrested in Florence at 4 o'clock Monday afternoon by Detective Atkinson of this city, assisted by the town marshal of Florence. Chamberlain was arrested at his father's house at Florence, in the presence of his mother, the other parent having come to this city to secure his son's valise, which was at that time in the possession of the Florence police. Chamberlain surrendered without protest, merely asking the detective, "Is that all?"

Chamberlain was arrested on a charge of forgery, but the real crime for which he was wanted was the murder of Kay. He has been trailed from one city in Colorado to another for the past six weeks, but each time had just left, and the search for him began anew.

Chamberlain was identified at 5 o'clock this afternoon by the young women from Denver and Pueblo, who were also walking to Pike's Peak on the night of Kay's murder and saw Kay and his companion. The identification is complete, though there are a great many other strong circumstantial points against him. Among these is the colored washerwoman who washed the clothes that Chamberlain wore on the night of the murder, and which were found a few weeks later by a young man from Cripple Creek, who was trying to locate a hidden toboggon [sic] on the cog road right-of-way. These clothes it will be remembered, were covered with blood, showing how the murderer had carried his victim after killing him. This colored washerwoman positively identified the clothes, owing to certain marks, one of which is large patch on the right leg of the under drawers. They are the same clothes which she claims she washed for Chamberlain a few days prior to the murder and ironed while he waited.

A day or two after Kay had been murdered on Pike's Peak Chamberlain purchased a suit of clothes of the Russian Jew, Schmidt, at the latter's shop west of the Huerfano street viaduct. As part of payment for the clothes officers say Chamberlain gave Schmidt the watch which Kay wore on the night he was killed, and which the murderer took, together with all Kay's money. Schmidt in turn sold the watch to a local pawnbroker, where it was discovered by Detective Atkinson. Kay's watch, however, was not found until after Schmidt had been murdered, and how Schmidt came into possession remained a mystery. Schmidt, however, told the pawnbroker that he had secured the watch from a young man as part payment for clothes, but did not give the young man's name.

It is claimed by officers that Chamberlain returned to Schmidt's shop and that the Jew informed him of the selling of the watch which Chamberlain had given in payment for clothes. The police assert that Chamberlain, realizing that if the chain of evidence was not broken be either Schmidt's disappearance or death, the murderer of Kay could be easily traced by reason of his pawning the dead man's watch.

Schmidt was murdered on the night of September 2nd in cold blood. The Jew was shot through the forehead and his body hidden under old clothes. The murderer then tacked newspaper over the small windows which the shack boasted and padlocked the door from the outside. Schmidt's body was robbed, and the watch bearing the name "Jennie" was also taken. This lady's watch had been purchased by Schmidt from the same pawnbroker to whom he disposed of Kay's watch.

COASTING DOWN PIKE'S PEAK

W.E. PERKINS TELLS HOW HE RODE HIS BICYCLE DOWN COG ROAD

NINE MILE TRIP DOWN 25 PER CENT GRADES TOOK 2 HOURS AND 20 MINUTES

ONLY MISHAP WAS THE FAILURE OF THE HAND BRAKE ALMOST AT THE START

TEMPORARY BRAKE QUICKLY FITTED UP WITH ROPE AND A BLOCK OF WOOD

Rocky Mountain News
December 26, 1897

W.E. Perkins is considered the most venturesome of the down hill riders of the state. Going down hill on a bicycle is a difficult feat, but Mr. Perkins has reduced it to a science. Riders say that he delights in riding on the ties through the mountains, and is inclined to object when a level stretch is reached. E.H. Perkins, brother of W.E., has done some riding, but nowhere

W.E. Perkins and other gnarly dudes of the Denver Ramblers Wheel Club cool their heels on the summit, 1891. *History Colorado.*

in comparison to the smaller member of the family. The most difficult feat ever accomplished in the state was the descent of the cog road on Pike's Peak on a safety. Mr. Perkins has written for the *News* how the achievement was accomplished, and also of the long list of feats that led him to attempt the descent. His account reads:

> *The bicycle as a means of locomotion, was certainly hardly popular in mountainous districts and not particularly practicable, until the advent of the cushion tired safety in 1891. Up to that time I had made but one tour of any pretensions, when, with Herbert Kennedy, the year before we introduced the first bicycle into the thriving settlement of Steamboat Springs, on the banks of the Bear river, after a dangerous, though delightful trip over Berthoud Pass and the Gore range. "Goats" had been ridden to some extent*

from the earliest days of cycling, but the light roadster of the latter days of the '80's had almost entirely eclipsed them, and for anyone to predict a return to the low-wheeled machine seemed a recklessness born of ignorance. At first vague rumors of large tires filled the atmosphere, and we wondered how they were to be applied. Then it was said that a revolution was in the wind. We would come down to riding safeties [new-model bicycles]*; which would have inch and a half tires, and some even whispered of inflated tires. The fall of 1890 brought in a cushion safety* [rubber tube tire]*, but we looked upon it with more or less contempt. Before the riding season of 1891 fully opened up we disposed of our ordinaries* [old-model bicycles]*, at any sacrifice.*

THE CUSHION SAFETY

My first impression upon seeing the cushion safety was that it would be the only mount for me, as it would so equalize the mountain roads as to make mountain cycling a pleasure instead of a task, and that impression has been fully realized, though I once doubted its displacing the good old ordinary on prairie roads. My first ride under the new conditions was over Mount Lookout and down Chimney canon to Golden, a trip I had made some years previously. Chimney canon is appropriately named, and I had some doubts as to my ability in riding the steepest of it, my mind still carrying a picture of the difficulties of my earlier trip. The turn around "Cape Horn," was made so easily that I felt perfect confidence in riding the rest of the grade. I was accompanied on this trip by an old pioneer, H.G.Kennedy, who was equipped same as myself. We experienced one of those thrilling incidents which occasionally happen in life—thrilling to me because it was new, and also by contrast with my former descent of this same canon by wheel. Partly coasting, partly pedaling, always with a firm grip on the brake lever, going like the wind or sliding the rear wheel as the condition of road admitted, we made the canon ring with our shouts, and almost in the time it takes to tell it we were fairly flying down the gradual slope beyond the mouth of the canon.

This adventure made me thirst for more hills to conquer, and I commenced to plan for mountain rides and tours. In laying out a [Ramblers] *club tour for that year the idea suggested itself of coasting the carriage road down Pike's Peak, so I determined to try it. C.C. Candy and H.G. Kennedy accompanied me on this trip, and on June 29 we made a successful ascent, pushing our wheels up the cog road, and in the afternoon made a flying trip of twenty-eight miles into Colorado Springs in two hours and forty minutes.*

DIFFERENCES IN BRAKES

The succeeding years ushered in the pneumatic in all its glory, and the frailty of the tires not permitting spoon brakes, my wheel was always equipped with a band brake, without which no one can enjoy a diversity of coasting to the fullest extent. During the first year of the pneumatics I gave them a thorough test on the Middle and North Parks, Laramie plains and Estes park circuit, becoming fully convinced as to their reliability. A few days after returning from that tour I learned that a party of wheelmen intended taking the Pike's Peak carriage road coast, and who, as a discretionary measure, temporarily resumed the last year's cushion.

My kite or racquet frame, which I had been riding as an experiment, had failed to stand the racket and was in the shop, but being determined to again enjoy that wonderful coast, I procured the only available wheel, a twenty-eight pound racer with pneumatic tires, without brake coasters or other weighty appliances. A pair of coasters fitted me for the trip.

The first part of the coast was rather tiresome, in this case, as depended entirely on my feet for braking, but about timber line I secured a small stick which I fastened to the rear forks, pressing hard upon the rear tire. This gave resistance, and relieved my muscles of considerable strain. It is a much more satisfactory impromptu brake than can be devised by tying a log or brush to drag behind as practiced by some. I found that the wear was all on the stick, and not on the tire. I have always found enjoyment in riding over the various passes in Colorado, mainly from descending, and only once found a pass where I was obliged to walk any portion going down. That was Ophir Pass, between Silverton and Ophir, over the San Juan range.

For a mile down the west slope, the rocks, of which the road surface consists, were shell or rocker-shaped, and large enough to strike the rear tire several inches from the ground as soon as the front wheel bore down on them beyond the center.

FIRST THOUGHTS OF COG ROAD

I had no idea at the conclusion that there was no wagon road steep enough to deter me from making the descent and really felt a desire to learn where my limit was. At some time or other the cog road on Pike's peak entered my mind as a good field for a new experience, and I wondered how a wheel would act on that 25 per cent grade, but nothing arose me to that feat until the summer of 1896, when I was stationed at Colorado Springs. One day

while in conversation with a gentleman about cycling in general I casually mentioned my trip down Pike's peak. "What down the cog road?" was the reply. I pitied his ignorance, and explained about the grade, when he remarked, "I thought it was impossible to ride a wheel down there." I did not see where the impossibility came in, and on my next trip up the peak, I carefully noted the grade and weighed the conditions and later on confided to a couple of friends that I was going to down the cog road on my wheel before leaving the Springs. They took it for a joke, of course, as their incredulous smiles plainly indicated.

On the 20th day of August I called on a friend who had helped me occasionally in the office, and requested him to run the agency while I took a little ride from the signal station, down the cog road. His appeal to me to forego the pleasure was readily touching, though, I was considerably amused at his fears. I tried to impress him with the simplicity of the undertaking, but if he had had any authority beyond friendly remonstrance he would certainly have exercised it.

Catching the last of three trains up the peak that afternoon, with my wheel on the rear platform, I was soon enjoying the anticipation of an uncertainty, though I felt not the slightest trepidation or nervousness. It was very easy to realize that if my wheel got beyond control on that tremendous grade it would probably be my last trip, but such a condition seemed as remote as for my feet to get beyond control while walking down the street.

On Pike's Peak

A friend who was at that time operator at the signal station, invited me to spend the night on the peak, and make the descent in the morning. As it had showered several times during the afternoon with prospects for more rain, I availed myself, through his kindness, of a night on the peak. The night was cold and windy and anon an immense cloud would envelope us, dashing sleet against the windows while flashes of lightning illuminated the apartment where we hovered around the big stove telling stories of mountain adventures. I ventured out of the warm shelter to get the full benefit of the situation. If the platform on which I was standing had not been so steady I could have imagined I was out in a heavy storm on the ocean. Huge billows of cloud rolled up from the southwest with the motions of waves so realistic that it seemed as if each one would lift me onto its crest and carry me out into space. The lightning played from below these clouds, reflecting its red glare from above and through them, showing here and there an outline

of mountains and hills followed by immediate blackness. Suddenly every cloud had disappeared to the east, where the storm mass could be seen by the intermittent flashes. The lights of Denver, Pueblo and Cripple Creek indicated their location, while each individual electric light in Manitou, Old Town and Colorado Springs scintillated like a diamond.

During the two or three hours preceding sunrise we were disturbed by the footers, who came during all hours of the night.

The signal station on the summit is at the altitude of 14,147 feet, or 7,518 feet higher than Manitou station of the Pike's Peak railway. The distance by rail being 8.90 miles. The cog road, completed in 1891, consists of two lines of rails, a double cog rail in the center and on each side between the cog and the outer rail is a spiked plank running parallel with the rails, the entire length of the road with the exception of about a mile across Ruxton park, where the grade is very light.

THE FAREWELL.

At 11 o'clock, after my friends on the peak had bidden me good-bye and promised me a decent burial in case their worst fears were realized, I lifted my wheel to the plank, and making the pedal mount, commenced the most unique trip in all of my cycling experience. My band brake worked to perfection and when I struck the first steep grade over the summit I found that with my foot on the coasters I could maintain a gait of almost six miles per hour, beyond which I did not think it safe to go. I heard a farewell cheer from my friends, who had walked up to the edge of the grade to see how I progressed. Soon my brake commenced a wail which gradually increased to a shriek, so loud and shrill that it seemed to awake the echoes from the distant range. A party of tourists on horseback had just reached the point of the V in the wagon road as I dropped past them. They shouted some facetious remarks, but I was too busy to do more than give them a glance and reply that I did not have time to talk to them.

Fortunately the entire scenic surroundings were familiar, as I was obliged to rivet my attention to the plank, which was not wide enough to permit the slightest deviation of the front wheel. Suddenly my wheel made a dive ahead, and only instant action prevented the prophesied catastrophe, as I was at that time on a portion of the 25 per cent grade. With a quick movement my foot was in the front forks, then with a spring, I cleared the entire wheel, landing on my feet a short distance ahead. Something had happened to the brake, but I could not discover what it was at first. Upon

examination I found that the drum, which was threaded and screwed onto the threaded hub of the rear wheel was loose and refused to revolve with the wheel. The intense heat had expanded the drum until the strain stripped the threads. I was now about half a mile from the summit without a brake. It was impossible to hold the wheel a single revolution by back pedaling, but knowledge is power in cycling, as well as other affairs of life. I had with me a piece of small sized rope, and after a few moments search found a small block of wood. Tying one end of the rope to the frame near the rear axle, running it across the top of the block, which was resting on the rear tire, against the forks, and tying the rope similarly at the opposite axle, I had an impromptu brake, easily adjustable, by loosening or tightening the rope. But another difficulty presented itself. With my brake I could no longer hold the plank over owing to the unsteadiness of the brake from the inequality of the circumference of the tire. This meant three miles of bumping ties— not unlike a ride downstairs—until I should reach timber line, below which the ties were evenly ballasted. Dropping from tie to tie was an amusing though not comfortable diversion. At a short distance about the Saddle house a section gang was repairing the road bed, having removed the ballast for about 300 feet. I walked over this and was informed by the foreman that I would have to walk a couple of miles further, but as soon as I had passed him I was beyond their work, and mounting again covered the next two miles, past the Saddle house to Windy Point in about six minutes. Below Windy Point a bad stretch of ballast compelled me to a further walk of several hundred feet, after which the riding surface became better. A party of tourists whom I passed about timber line, said they never would have believed it possible for anyone to ride a bicycle down that grade if they had not seen it ridden. Coasting and back pedaling, I reached Ruxton park, which I crossed without releasing my brake, as there is a heavier grade than a person not on a wheel would imagine. At 12:35 I telegraphed my friends on the summit, from the Half-Way house. The rest of the descent was a very easy matter, as my riding surface consisted mostly of graphite at the side of the track. At 1:20 I pulled up at the Manitou station after the most interesting, nine-mile spin it was ever my good fortune to take.

Dead Body of J.M. Holmes Found in a Snowbank Near Power House No. 2 – His Companion, N.S. Thorpe Was Badly Frozen – Five Days in a Snowstorm – Lost Mine of Tradition Lured a Prospector to His Death – Coroner Will Go Up Today

Colorado Spring Gazette Telegraph
February 6, 1899

After wandering for four days on Big Horn mountain and Pike's Peak, J.M. Holmes, a veteran prospector, who was lured to the Peak through traditional stories of lost mines, finally succumbed to the raging blizzard and lay down in the snow to die, Friday night.

The dead body was found only a few hundred yards from power house No. 2 yesterday morning at 10 o'clock by Assistant Engineer Durfee and Geo. W. McGovern, while the man's companion was discovered in a cabin nearby. Thorpe was in a badly frozen condition from his terrible experience in the blizzard, but he will recover.

Lost in a Snowstorm

Just five days ago Holmes and Thorpe started from Cripple Creek bound for the former's cabin, away up on the precipitous sides of Pike's Peak about half way between the timber line and the summit. Holmes had been working a claim in this inhospitable region for the last 18 months. The two men were well provisioned for they anticipated a long stay at the cabin where they expected to continue their search for gold.

The first day a terrible blizzard swept the mountains and snow fell so rapidly that the trails were completely obliterated. In many places the snow was 15 or 20 feet deep. For two days the unfortunate prospectors wandered over Big Horn mountain, completely lost. The thermometer dropped to ten degrees below zero and it was with difficulty that the men kept from freezing. Finally they wandered into the gulch below reservoir No. 2, and here again they were lost for two days. Their feet and hands were badly frozen and it was with utmost difficulty that they dragged their nearly exhausted bodies over the rocks vainly looking for a place of refuge.

At last human nature could stand the strain no longer, and on Friday night Holmes lay down to die while in sight of the lights at Strickler tunnel. Thorpe

remained by the side of his companion all night. Worn out, exhausted and half frozen, he finally reached a cabin Saturday night, barely escaping with his life.

LURED TO DEATH BY GOLDEN SIREN

The story of the sufferings and death of Holmes and almost miraculous escape of Thorpe brings out an interesting romance, for Holmes, who was prospector of many years experience was simply lured to his death by a golden siren.

For many months the prospector had been digging for gold at a point on the Peak about 13,000 feet above sea level. A story of marvelous riches being found on the Peak by an old German away back in '58 or '59 had excited Holmes and he labored under the hallucination that he could re-locate this lost mine, which tradition said was fabulously rich. For many months the prospector had prosecuted his lonely search, never losing faith, but always certain that eventually he would locate the lost mine which would startle the world by its richness. His trip to Cripple Creek was made for the purpose of securing provisions and a partner to help him in the continuation of his hope, and filled with hope, he was returning to the mine when death overtook him in a raging blizzard.

BODY STILL IN SNOW

When Thorpe was found in the cabin yesterday morning he was taken up to the Strickler tunnel by Bert Ward who was accompanying Engineer Durfee, and after having been partially thawed out, he told the story of his wanderings.

Holmes' body was located in a snow drift but it was not removed. Coroner Hallett was notified and he will go up today and bring the body down to the city. Holmes was a man about 65 years of age and it is thought that he formerly lived in Colorado City, but none of his relatives could be located last night.

A peculiar coincidence in regard to the freezing to death of Holmes is that the dead body of a man was found at nearly the identical spot where Holmes' body now lies, on the 15th of last March. The man was never identified. An examination at the time showed that the body had probably been in the snow for several months before it was discovered by a party of surveyors in the employ of the new railroad at Cripple Creek.

Rocky Mountain Sun

May 27, 1899

Nikola Tesla is in Colorado and announces he will attempt to send a message from the summit of Pike's Peak to Paris by wireless telegraphy. He does not say that he expects to succeed, and there is no strong reason for believing that he anticipates success, says the Statesman. Nikola, in recent has become very much of a personal advertiser; he is always before the public with glowing forecasts of what he is going to do, but his record of achievements is all in the more or less distant past.

While he was climbing the ladder of fame in the scientific world he accomplished wonderful results, but since he reached the top he has shown a disposition to wave his hat and call attention to himself. It is not surprising to find him planning a performance from the summit of Pike's Peak.

Rocky Mountain Sun

July 1, 1899

An enormous column of red fire will be sent up from Pike's Peak on the night of July 4. It is expected that the illumination will be visible for a distance of two or three hundred miles. People living at a distance from Little Lunnon who perchance have not heard of feeling for the natal day of the Yankee bird, will imagine that [President] Billy McKinley or [Senator] Ed Wolcott has visited the city of one lungs and that elated inhabitants are burning the town down to demonstrate the ecstatic joy they would feel at being thus favored by their idols.

Pike's Peak Blazes Behind Black Clouds

Denver Times
July 4, 1899

The illumination of Pike's peak was not the glittering success anticipated by the enthusiastic promoters of the idea. The sky which in the morning was without a cloud became overcast in the afternoon, while in the evening it was inky black almost, especially toward the south.

Although it was a hard fight the men on the peak carried out their program and burned 1,500 pounds of red, white and blue powder in the presence of Mayor Johnson of this city and his party of Denver officials. The best view was from Colorado Springs. The illumination was started about 9 o'clock on account of the threatening clouds and the arrangements were carried out and the red, white and blue were burned in rotation and then together, but the powder soon grew so damp that it would not burn.

As viewed from Denver the illumination was something of a failure, but the reflection of the fire against the sky could be seen from the south part of the city, from Highlands and from the high office buildings.

ROCKY MOUNTAIN SUN

July 8, 1899

"That illumination of Pike's peak was big fake; even as near as Colorado Springs the light was not as big as the match." Thus delivered himself as man who was there and ought to know what he was talking about. "But it was cloudy," interjected a listener. "Cloudy, nothing! 'Twas a humbug." And now you have the much-talked-of event from another point of view.

J.M. Richards has returned from Denver where he spent the Fourth with his family. He says a terrific thunder storm was raging between the city and Pike's peak at the time of the illumination of the mountain and only those people who had peculiarly advantageous points of observation could catch a glimpse of the colored fire. In Highland it was said the view was best.

MANITOU AND PIKE'S PEAK DAY EVENTS FOR 9/14

Colorado Springs Gazette
September 13, 1899

9 a.m.—Ascension of the Famous Cloud-piercing Peak.
3 p.m.—Balloon Ascension.

Chamberlain Dead: Murder of Herbert H. Kay Breathed His Last in Penitentiary Yesterday

Colorado Springs Gazette
October 12, 1899

Canon City, Colo.—S.D. Chamberlain marks the final chapter in the worst tragedy ever known in Colorado Springs. The murder of Herbert H. Kay, which occurred on Pike's Peak during the early morning hours of August 19, 1897, startled the entire state, and the subsequent arrest and trial of Shirley D. Chamberlain proved the most sensational ever known in this city.

Summit Pikes Peak. Perpetual Snow. *Photo by Thurlow, J. (James Thomas), 1831–1878. Library of Congress.*

Kay was a young Nebraskan who was out here sight-seeing. He walked to the summit of Pike's Peak one night and the following day his murdered body was found under a culvert near the summit. The "Pike's Peak murder mystery" puzzled the authorities for many months, but finally after a long chase, he was run down by Detectives Atkinson and Chief Gathright.

…Thus the final curtain is drawn on the bloodiest and most sensational tragedy ever known in the Pike's Peak region.

RELIC OF THE PIONEER DAYS OF '58

Georgetown Miner Letter
March 9, 1901

A relic of the pioneer days in Colorado, which is probably the only genuine record of the first party of white men who are known to have ascended to the summit of Pike's Peak and left a substantial proof of their visit, has recently been discovered by August Hueber, a prospector who lives at Manitou. It is a stake which he found among the rocks on top of Pike's Peak, on which was carved the names of a party of adventurous spirits who succeeded in making the ascent of the peak in 1858. The stake was left there by them as evidence of their visit to this lofty summit long years before Colorado had entered the list of civilized communities.

"The Storm Passing Below." Pikes Peak Summit, circa 1890–1900. *History Colorado.*

The stake is a piece of pitch pine which is almost as lasting as iron, and the names which were carved on it have withstood the ravages of time to a remarkable degree, although some of the letter are almost entirely effaced by the action of the elements. The stake is about thirty inches long, two inches wide and over an inch thick, rather irregular in outline, as though it had been trimmed down with a pocket or hunting knife before the names were cut deep into it by the men whose names it bore.

One on side was carved the name "AUGUSTUS VOORHEES, July 10, 1858." This name and especially the date were quite distinct, although part of "Augustus" is almost worn down to a scratch. On the reverse side is dimly traceable the name "J. -iller." Preceding the name is the date, "July 10, 1858," which is nearly defaced and...can not be successfully deciphered even with the aid of a magnifying glass.

One of the narrow sides of the stake bears the faintly discernible inscription, "F.- Cobb," and some other faint marks which could not be deciphered.

On the opposite side was another name, but only a portion of the original letters can be made out...the last two words probably being "Lawrence, Kansas."

Mr. Hueber found the stake among the rocks of an almost inaccessible point which overlooks "Dead Man's Gulch," and the fact that the point was so difficult of access probably made it a most inviting place for the adventurers to put their stake, as it was apt to remain there longer than if placed elsewhere. Although it was left there over forty years ago, it shows absolutely no sign of decay, but the surface is considerably weather worn and the names which were cut deep into the wood have gradually been defaced by the wind, rain and snow which for years beat into the secluded notch in which the stick was secreted. The fact that the wood was pitch pine readily accounts for the remarkable state of preservation in which it was found, after lying so long.

Hon. Anthoney Bott of Colorado City, who arrived there in 1858, with a party of fifty men and one woman—Mrs. [Holmes or] (Countess) Murat, who is still living in Palmer Lake—stated that the men were members of the Lawrence, (Kansas) party which arrived there some months before, during the early summer, and camped for two or three months in the Garden of the Gods and vicinity.

...Realizing the great historical interest which might be attached to this stake, the writer had it photographed and has made diligent effort to establish its genuineness. These efforts finally resulted in ascertaining that Mr. J.D. Miller, president of the J.D. Miller Mercantile Co., of Pueblo, was one of the first members of the Lawrence party who ascended the peak, and

an inquiry was sent to him for further light upon the subject, to which the following reply has been received.

—Fred L. Miner, Pueblo, Colo.
March 2, 1901

Fred L. Miner
Georgetown, Colo.

Dear sir:—I am in receipt of your favor of the 28th ult. And your inquiries revive memories of the past rather indistinct but which I like to talk over whenever I meet any of the old comrades. Frank M. Cobb, Augustus Voorhees and myself were the first party of the Lawrence company to ascend Pike's Peak in 1858, and I took along the stick as a cane and with a view of leaving our names on the Peak. When we first went there, there were no names to be seen, but there was a pile of stones two or three feet high, which we built up about five feet high and fastened the stick with our names in the center. It was cloudy the day we were on the summit, some snow flying and a cold wind blowing, and as we could not get a good view of the surrounding country we did not remain long. We started from our camp near the Garden of the Gods July 9th and camped under some rocks on the Peak about timber line, and on the 10th went to the top of the Peak, and about half way back to our camp, where we camped the night of the tenth and the next forenoon reached camp. A few days later James H. Holmes and his wife wanted to make the ascent of the Peak and as I had been up, asked me to go along and show them the way. On my second trip the party consisted of Mr. and Mrs. J.H. Holmes, George Peck and myself. Mrs. Holmes wore bloomers in order to travel over the rock and brush to better advantage and showed her good sense in doing so, as there was no trail and the way was rough.

—Letter by John D. Miller, 1901

CHRONOLOGY OF SELECTED
ASCENTS AND NOTABLE DATES

1779—Juan Bautista de Anza. South slopes of Pikes.

July 13–15, 1820—First *known* ascent by Edwin James, Lieutenant Swift and French guide "Bijeau."

October 1839—Several hundred Indians reported to have climbed the peak during inter-tribal gathering at Manitou Springs.

July 8, 1858—Frank M. Cobb, John D. Miller and Augustus Voorhees of the Lawrence, Kansas wagon train.

August 5, 1858—Julia and James Holmes, also of the Lawrence Party, accompanied by John Miller and George Peck.

October 1873—U.S. Signal Station established on Pikes Peak summit.

November 22, 1873—Grace Greenwood to signal station.

July 1, 1874—Party of visitors caught in thunderstorm at the summit, singed.

Summer 1878—The Pikes Peak Trail, following Ruxton Creek, was completed.

July 29, 1878—Professor Langely, eclipse.

July 12–13, 1879—Henry L. Stearns (solo).

August 21, 1885—Richards party, with first baby to summit on horseback.

June 28, 1887—Frank Stevens and party.

Summer 1887—The first rough wagon road from Cascade to the summit was opened.

September 6, 1888—Press excursion to summit.

October 18, 1888—U.S. Signal Station "officially" closes.

June 30, 1891—First cog train to the summit.

1893—Katherine Lee Bates summits. Writes poem "America the Beautiful" in 1895.

July 26, 1893—Mabel Loomis Todd and party.

July 4, 1899—Colorado Springs Mayor Johnson, Denver officials, for fireworks party.

Please note: tourists of the nineteenth century had a different ethic and may have had certain practices that we find appalling or, at least, illegal. Therefore, *please do not* pick flowers, roll rocks, discharge firearms, use whiskey or brandy as an altitude curative or coast down the cog road on improvised sleds or bicycles.

<div style="text-align: right">

Thank you,
The Author

</div>

ABOUT THE AUTHOR

C olorado Mountain Club historian since 2003, Woody has hiked to the summit of Pikes Peak twice, reached the summit once by car and once by cog rail, climbed eighty-five of Colorado's one hundred highest peaks, made a few minor discoveries including a probable first-known ascent of Kit Carson Mountain in 1883 and led a successful 2005 effort to name Colorado's seventy-fifth highest peak for Mary Cronin—the first woman and fourth person to climb all of the state's fourteen-thousand-foot peaks, finishing in 1934.

The author on the Longs Peak Trail, July 23, 2014. *Jennifer Novich photo.*

Visit us at
www.historypress.net
...

This title is also available as an e-book